*The College History Series*

# STATE UNIVERSITY
# OF NEW YORK
# COLLEGE AT ONEONTA

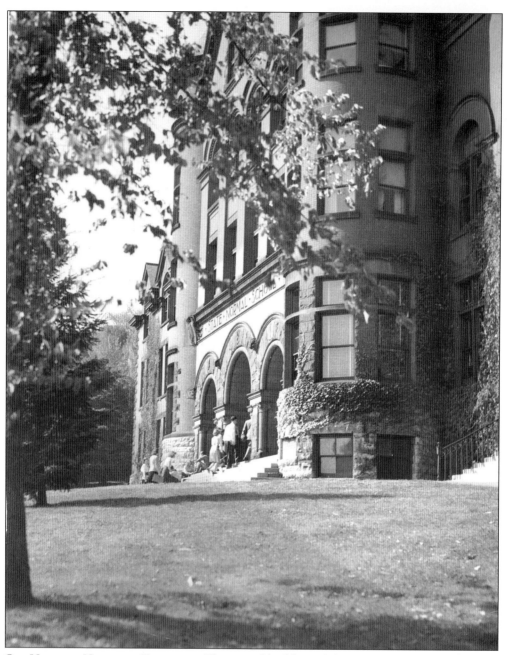

**OLD MAIN, THE MAJESTY OF YESTERYEAR.** The central building of the Oneonta Normal School was Old Main. This view looks up from the right side of the lawn. Old Main served the college for nearly three quarters of a century as an administrative building, classroom, gymnasium, laboratory, auditorium, and training facility.

*The College History Series*

# STATE UNIVERSITY OF NEW YORK COLLEGE AT ONEONTA

DAVID W. BRENNER, PH.D.

ARCADIA

Published by Arcadia Publishing,
an imprint of Tempus Publishing, Inc.
2A Cumberland Street
Charleston, SC 29401

Printed in Great Britain.

Library of Congress Catalog Card Number: 2001097587

For all general information contact Arcadia Publishing at:
Telephone 843-853-2070
Fax 843-853-0044
E-Mail sales@arcadiapublishing.com

For customer service and orders:
Toll-Free 1-888-313-2665

Visit us on the internet at http://www.arcadiapublishing.com

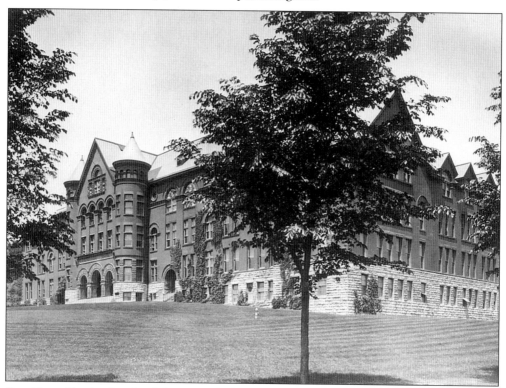

OLD MAIN. The landmark of the normal-school movement in New York State was a central building that initially housed all of the school's functions. In this photograph we see the second Oneonta Old Main. The first was destroyed by fire on February 15, 1894, after less than five years of use. The rebuilding of a new Old Main started immediately, and by September 5, 1894, some classes were being held in the building. Old Main was rebuilt at a cost of $250,000 and remained in use until 1975.

# CONTENTS

STATE OF NEW YORK

GEORGE E. PATAKI
GOVERNOR

The citizens of the Empire State are proud of its institutions of higher learning that serve as foundations for the intellectual growth and enrichment of our population. For more than 50 years, the 64-campus State University of New York has provided academic excellence and educational opportunity for all New Yorkers. Founded in 1889 as the Oneonta Normal School, the College at Oneonta has been an integral part of SUNY since its inception as a teacher-training institute, and in more recent years, as a multi-purpose college of the arts and sciences. Throughout the years, the 44,000 alumni of the College have gone on to earn national and international distinction for their achievements in education, the arts, law, business, politics, science, athletics and community service.

Today, the College at Oneonta enrolls more than 5,600 students in a full range of undergraduate and graduate programs. Its tradition for excellence in preparing future educators continues and is complemented by strong programs of undergraduate study in business and economics, music, the arts and sciences, and the well-recognized Cooperstown Graduate Program in History Museum Studies. Central to the College's success are more than fifty faculty members who have been named as recipients of the SUNY Chancellor's Awards for Excellence and eleven who have received SUNY Distinguished Professorships. The College at Oneonta's goals for teaching and learning are strengthened by advanced current technology, which is visible in the extensive campus network, technology-enhanced classrooms and computer labs found in each building. The new Alumni Field House, sports facilities and playing fields support a first-rate athletic program that includes outstanding men's and women's soccer teams. In the past five years, private scholarship awards at the College have nearly tripled, expanding opportunities for New Yorkers who wish to pursue their dreams of a higher education.

The College at Oneonta continues to fulfill an important public service mission in Central New York State. Its students have a long history of service to the community, and the College's Center for Social Responsibility and Community has received national recognition as a model volunteer service program. To the City of Oneonta and Otsego County, the College is a vital resource, hosting cultural events on campus and sharing expertise off campus through its Center for Economic and Community Development. As such, the College fulfills its commitment to excellence in many areas, which is the fundamental purpose of any community.

In 1889, Principal James M. Milne dedicated the Oneonta Normal School with these words: *I see possibilities full of promise: today we dedicate; tomorrow we change possibility into reality.* For more than 110 years, as this book so well documents, the SUNY College at Oneonta has turned possibility into reality for thousands of residents of New York State and will continue to do so for generations to come.

George E. Pataki
Governor

# INTRODUCTION

This volume is dedicated to the seven people who have served as principal or president of the State University of New York, College at Oneonta, during its more than 110 years of existence.

While there are those who speak of Sir Thomas More as "a man for all seasons," it is the author's opinion that each of Oneonta's presidents was exactly the person for his season.

James M. Milne, Oneonta's first principal, was a first-rate teacher, orator, organizer, and scholar. His energy and interests were wide ranging. He also had 16 years of experience at Cortland Normal School and was exceptionally well equipped, emotionally and physically, to tackle the problems of starting a new institution. In fact, Milne even had to begin again after the disastrous fire of 1894.

In the wake of the controversial firing of Milne, Percy I. Bugbee was appointed principal in 1898. For the next 35 years, Bugbee administered the institution. He was well respected by all the groups he dealt with, including faculty, students, and townspeople. His priorities—the development of student character and intensive supervision and training for teachers—remain today among the preeminent goals of Oneonta.

In 1933, Dr. Charles Hunt became principal. He was a democratic decision maker and a firm believer in faculty participation. Above all, Hunt was a visionary, dreaming of an expanded campus, full status as a degree-granting teachers college, and Oneonta as a receptive environment for experimentation and innovation.

With the appointment of Dr. Royal F. Netzer in 1950, Oneonta gained an administrator who was able to put Hunt's dreams into reality. Netzer was very interested in expanding the campus to the hill acreage purchased during Hunt's time and overseeing the building of the facilities necessary for future enrollment increases and program expansions. Well respected, both locally and in Albany, Netzer provided excellent leadership during his tenure, retiring in 1970.

Dr. Clifford J. Craven was appointed president in 1971 and immediately turned to the business of college governance and administrative reorganization. In particular, he was concerned that faculty and student complaints be addressed as quickly as possible. Additional efforts were made in the minority recruitment area. Craven encouraged collaborative efforts, often involving faculty and students, regarding promotions and recruitment. Long interested in international education, he initiated several foreign-exchange opportunities. He saw the need for a strong alumni association, a fundraising foundation, and several other entities—all designed to support the college's mission.

With Craven's retirement in 1987, Dr. Carey W. Brush was named as acting president. Brush had served in an acting capacity during several of Craven's study leaves and was well regarded by the faculty.

Dr. Alan B. Donovan was appointed the sixth permanent Oneonta president in 1988. A Williams College graduate and a Yale Ph.D. (along with extensive administrative experience), Donovan was well prepared to lead the college. With retirements occurring, he moved rapidly with new appointments. His comments and formal addresses emphasized "planned change," economic and community development, public service, beautification and maintenance of the physical plant, and later, the development of character and responsibility—a theme that he aimed toward students. Later he followed these initiatives with the establishment and funding of centers necessary to address these goals.

As the new century unfolds, it is encouraging to quote from the college's statement of mission when it states that the college will foster the student's intellectual development through an emphasis on excellence in teaching, advising, and scholarly activities, along with a concern for the student's personal, cultural, and ethical well-being.

Yes, each of these presidents was indeed the person for his season—and SUNY College at Oneonta is all the better for it. Thus, this volume is dedicated to them.

—David W. Brenner, Ph.D.

# ACKNOWLEDGMENTS

The author is grateful for the opportunity to acknowledge the efforts and kind intentions of the many people who helped this volume become a reality.

First, a grateful thank-you is extended to Dr. Carey W. Brush, author of *In Honor and Good Faith*, a two-volume history of the SUNY College at Oneonta and the source material for many of the captions of this work.

Many thanks to the staff of the Huntington Memorial Library and of the James M. Milne Library, who have always been as helpful as possible. Please note that unless otherwise credited, all images are courtesy of the James M. Milne Library Archives at SUNY Oneonta.

Special thanks to Lois Brenner and Susan Haney, who helped in the typing of the manuscript. Thanks also to F. Daniel Larkin, acting provost, and Alan B. Donovan, president, for encouraging the author to take on this project.

A final note of appreciation to the Honorable George E. Pataki, governor of New York, for taking the time to write the foreword and, once again, showing his dedication and understanding of the need for the best higher education opportunities possible in our state.

# One

# ESTABLISHING THE
# NORMAL SCHOOL

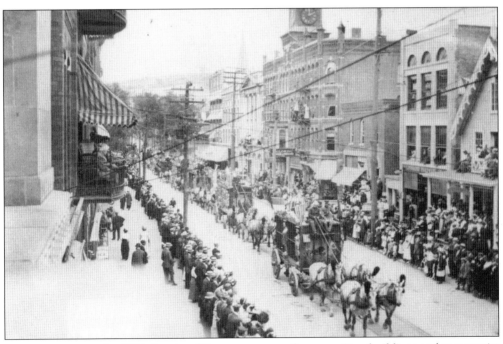

**A CITY PROSPERING.** In 1887, the city of Oneonta was on the move. New buildings and community improvements were increasing. Deposits in George I. Wilber's bank climbed past $500,000. Business activity expanded. As one looked about, prosperity was evident, but Oneonta's leaders wanted more. A new state armory building had just been completed. However, the newest idea was to locate a normal school in Oneonta, and several of the influential citizens embraced the idea immediately. (Courtesy of the Huntington Memorial Library.)

**WILBER'S ORIGINAL IDEA.** While Assemblyman Frank B. Arnold supported the establishment of an Oneonta Normal School, most observers felt the original idea came from George I. Wilber (shown), who envisioned it as an economic factor that would certainly enhance his interests, which included banks, streetcars, waterworks, newspapers, and real estate. Unlike his friend Willard E. Yager, Wilber had little or no interest in the cultural impact of an institution of higher learning. He served on the local advisory board and was eventually elected as its president.

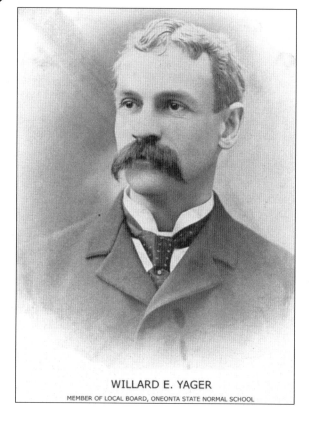

WILLARD E. YAGER
MEMBER OF LOCAL BOARD, ONEONTA STATE NORMAL SCHOOL

**NOT MY IDEA.** When the idea for a normal school was first discussed, some said it came from Willard E. Yager, local businessman and newspaper publisher. Yager thought the idea was a good one, praising it as a way of attracting people to the village for the purpose of intellectual and social stimulation.

**The First Principal, 1889–1898.** A successful teacher, a cultured man, a person of intellect, an individual with good judgment and a high energy level—all of these traits were used to describe James M. Milne. Three years after his initial hiring, the *Oneonta Herald* editor proclaimed that he was progressive, enthusiastic, devoted to education, and had excellent executive ability—the right man for the job. Milne labored hard, particularly after the fire of 1894. He suffered from exhaustion and took a short leave in 1895. Returning to health (and Oneonta), he seemed fit and ready for service. On February 26, 1898, the Local Board appointed Percy I. Bugbee principal. No explanations were given for Milne's dismissal. Some pointed to his disagreements with George I. Wilber over several school policy decisions. Others furthered the gossip item that he had been indiscreet with a woman faculty member. Milne moved on and became a successful attorney in his later years, dying of a heart attack in Waterville in November 1903.

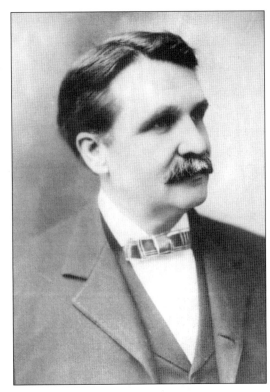

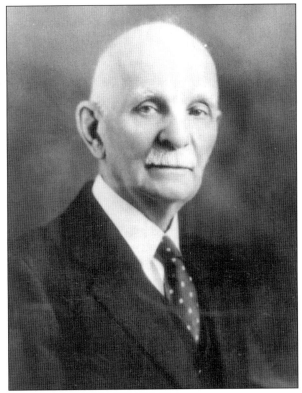

**The Gentleman Schoolman, 1898–1933.** Appointed as James M. Milne's successor, Percy I. Bugbee moved quickly to heal the wounds of the recent conflict over Milne's dismissal. Bugbee was the quintessential schoolman. He concentrated all of his attention on the faculty and students. Respected by all, he was frequently characterized as a beneficent authoritarian. The first part of Bugbee's tenure was described by some as the "dark ages," but from c. 1922 until 1933, attendance tripled and the school prospered under a state education department that became more involved in promoting (and regulating) teacher training. Bugbee was 75 years of age in 1933 and had completed 35 years as principal. He brought continuity and stability to Oneonta, leaving it a strong institution in emerging difficult economic conditions.

11

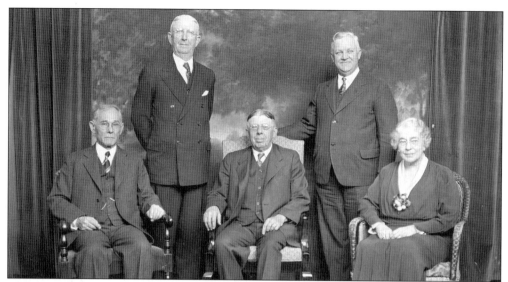

**THE LOCAL BOARD BECOMES THE COLLEGE COUNCIL.** In the early days, the Local Board was directly involved in the running of the normal school. In fact, the board fired Principal James M. Milne after a dispute that was never fully explained to the public. Board members scrutinized expenditures and participated in decision making of all types. Pictured above are members of the Local Board c. the early 1900s. They are, from left to right, ? Ford, Harry Lee, ? Rowe, Franklin Huntington, and Mrs. George Baird. Over the years, this oversight body evolved into an advisory group, leaving most administrative decisions to the staff. Members are appointed by the governor for seven-year terms. They have certain prescribed responsibilities, such as naming buildings, promoting programs of the college, and, most importantly, being a major player in the search for a new president when a vacancy occurs. Appointees are from the area or surrounding counties and are usually well known in their communities. Pictured below are members of the College Council c. 1969–1970, from left to right, as follows: (front row) W. Clyde Wright, Oneonta; Burton Hulbert, Oneonta; H. Gregory Lippitt, Cooperstown; Eleanor M. Rider, Edmeston; and Henry B. Whitbeck, Richmondville; (back row) Thomas J. Mirabito, Sidney; Alfred J. Studenic, Gloversville; Scott E. Greene, Cooperstown; and C. Vernon Stratton, Oxford.

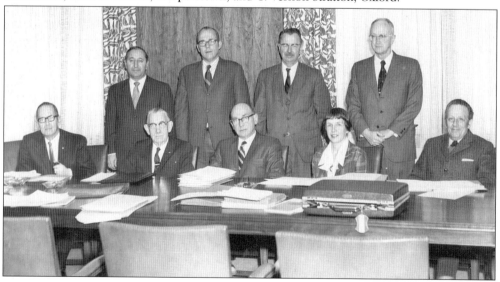

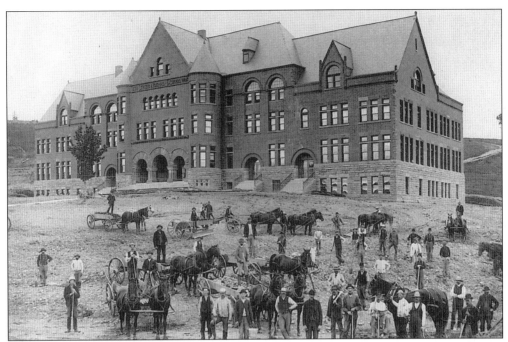

**THE NORMAL SCHOOL BECOMES A REALITY.** On Wednesday, September 4, 1889, the dedication of the original Old Main building was held. At this ceremony, Principal Milne said, "Today we dedicate; tomorrow we change possibility into reality; the school of today—cold brick and stone—becomes the living heart of tomorrow." In this photograph we observe 12 teams of horses, along with 45 men during the summer of 1889, all working to finish the building. At this time in New York State, there were 11 normal schools being proposed.

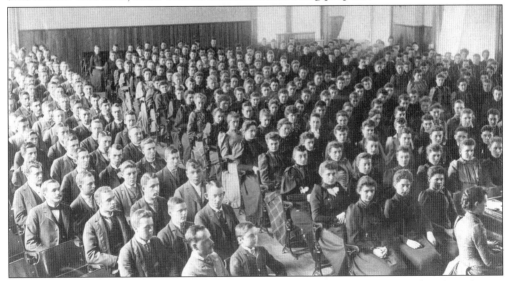

**NEW YORK PRIDE.** In 1893, exhibits from New York State were requested for the Chicago Exposition. Assemblies, recitals, and other normal-school functions were common at that time. With over a dozen normal schools functioning in New York State and teacher training receiving emphasis (particularly in rural areas), it was a source of pride for students and faculty to be photographed for part of a national exhibition.

13

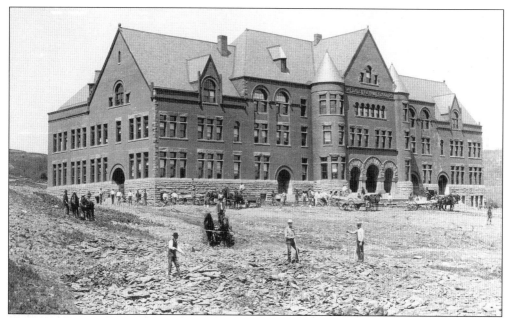

**A Tale of Two Buildings.** This photograph shows the first Old Main nearing completion. More than 130 men worked on the project. The photograph was taken during the summer and depicts 40 men on the site. After four and a half years of use, a fire destroyed the building, leaving only parts of the walls remaining. Appropriations were made and work started nearly immediately on the new building. The new Old Main was 30 feet longer across the front, and the wings were from 10 to 40 feet deeper. Construction proceeded rapidly during 1894, and the official dedication was held in December 1894, with some classes being held prior to the official ceremonies.

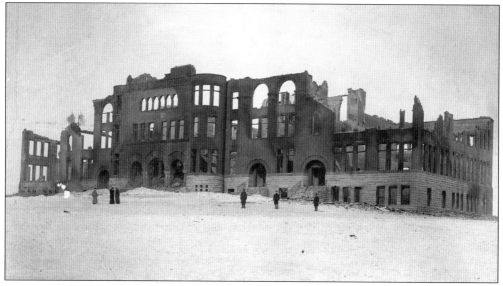

**Disaster Strikes.** On February 15, 1894, a fire broke out in the lower floors of Old Main. In a matter of minutes, the fire (fanned by high winds) raced throughout the building, which was eventually gutted. When Principal Milne was asked how long the school would be closed, he replied, "We haven't closed." Lectures and recitations began the following Monday. Less than two years later, a new Old Main was completed on the original site.

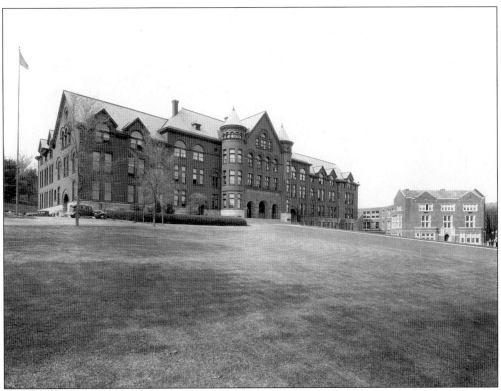

**THE NEW, IMPROVED OLD MAIN.** It cost the state $225,000 to reconstruct the normal school, which was nearly a duplicate of the old building. The new structure reopened in September 1894. Students and faculty contributed to the physical work of rebuilding, allaying fears that the normal school might leave Oneonta after the fire.

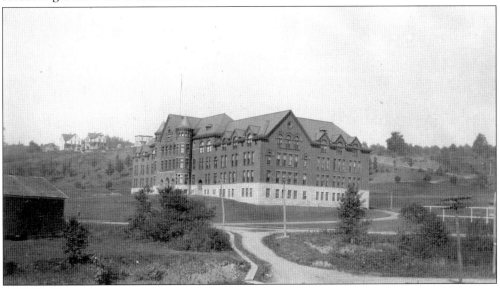

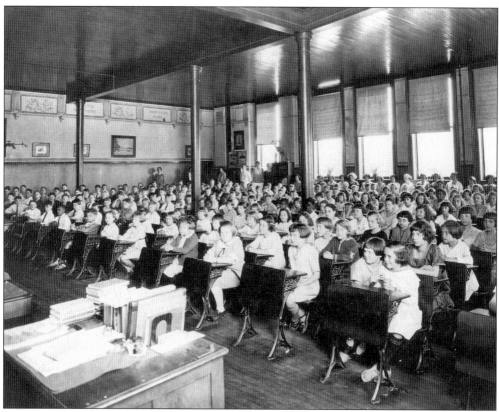

**PUBLIC SCHOOL CLASSES, 1905–1906.** Pupils attending public school in Old Main had many different experiences, including being exposed to student teachers, having additional field trips, and being assembled frequently for special programs designed to improve the training of new teachers.

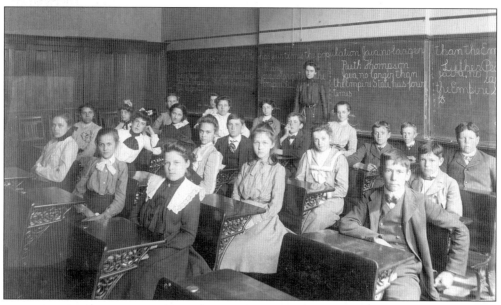

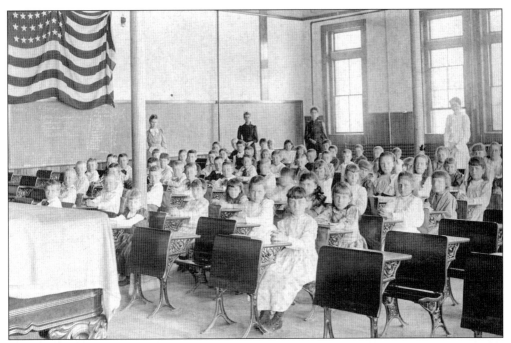

THE PRIMARY DEPARTMENT, 1892. Situated in one of the wings of Old Main, the primary grades had approximately 75 pupils. Class size for actual instruction would vary based on teachers available and the number of experiences the teachers-in-training needed. Pupils taught at the normal school (and later in the Bugbee School) were frequently thought of as saving the local school district money.

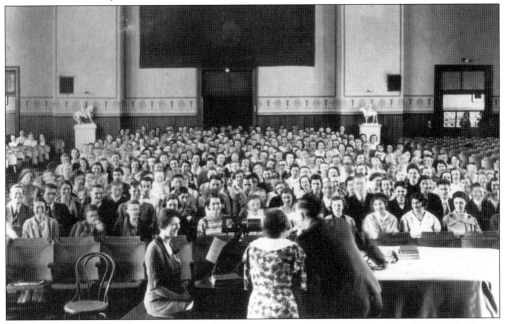

AN OLD MAIN ASSEMBLY, 1935. Not only did primary children assemble and sing regularly, but it was also an activity enjoyed by the college students. In this photograph we observe Ruth van Deusen (at the piano), Katharine Tobey, and John Wilsbach getting ready to lead a song assembly.

17

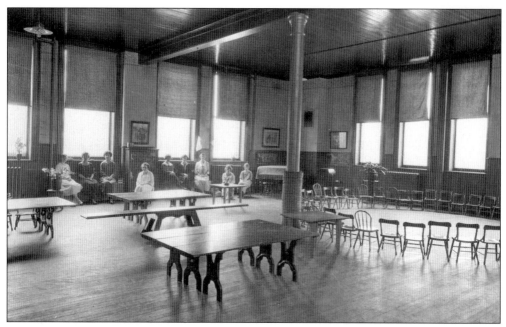

THE KINDERGARTEN WING OF THE NORMAL SCHOOL. New York State granted permission for all school districts to establish kindergartens, a movement that had begun in the 1850s across the nation. The Oneonta Normal School started a kindergarten in 1903, open to four-year-old children in Oneonta. Free play would last until 9:00 a.m., and then children would gather for instruction.

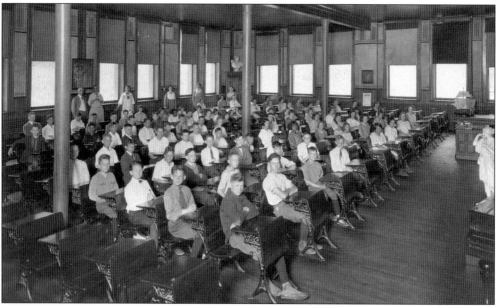

THE INTERMEDIATE SCHOOL CLASSROOM, 1905. Normal-school students were training to become teachers. The public school conducted at Old Main was open to Oneonta children who attended at a cost of $4 per quarter. Teacher trainees were under the watchful eye of critic teachers and supervisors. Pupils were taught to reason, think, make judgments, and study independently. They were also beneficiaries of the extra help provided by student teachers, especially in nature study, physical education, and one-on-one lessons.

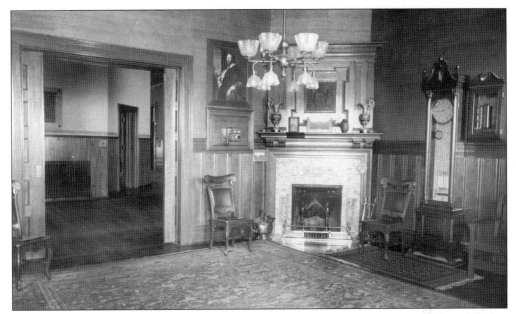

**SITTING ROOM SPLENDOR, 1934.** Old Main had many parlors and quiet rooms when it was first built. Some functioned for socials, student gatherings, and small-group seminars for a long time, while others were divided up and made into classrooms. By 1950, nearly all the space had been converted to either administrative or classroom areas. The room shown above was called the Senior Parlor. The Great Seal of New York adorns the area over the mantel of the fireplace.

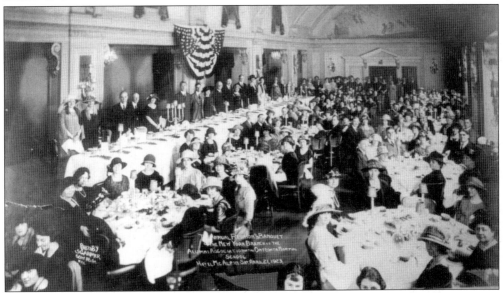

**ONEONTA ALUMNI BANQUET, 1923.** The Oneonta Alumni Association has had a long existence and excellent relationship with the college. However, it was not a prosperous organization or one that could help the college a great deal until the 1979 appointment of Robert MacVittie, a 1944 graduate and former president of Geneseo State University. During the 1980s, the Oneonta Alumni Association became one of the prime organizations supporting the college. Today, the association, led by Diane Davidson, is a force in fundraising, a responsive voice to those inquiring about their alma mater, and a source of significant financial help to those needing it.

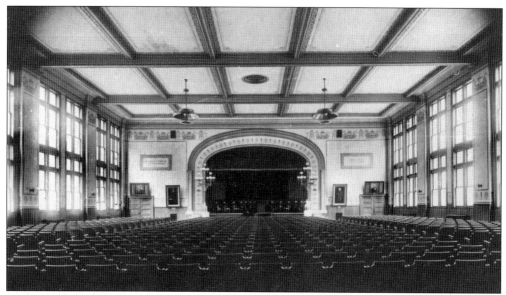

**CHAPEL HALL, 1914.** Old Main housed all of the major functions of the normal school. First opened in 1914, Chapel Hall was renovated in 1934 to include making about a third of the seats raised so that those in the rear could see better. Chapel exercises, including Bible readings and prayers, were mandatory for years. Commencement was held in the hall well into the 1950s. Plays, programs, and speakers—including Robert F. Kennedy, William O. Douglas, George Lincoln Rockwell, and Nelson A. Rockefeller—were presented in this auditorium.

**A SOCIAL ROOM, 1937.** Numerous gathering rooms were available in Old Main. In several of them, societies and sororities put up banners, decorations, and furniture, taking them over so that they became known as the Agonian Room, Arethusa Room, Clionian Room, and so on. The room shown was still undesignated and was available upon request. By February 1941, it had been converted to a girls' locker room.

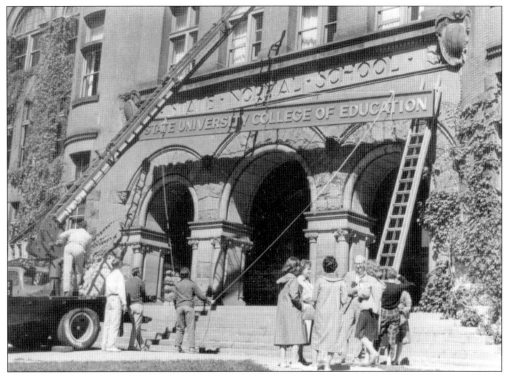

**THE NAME GAME.** Old Main was not only the major facility of the institution for the first half of the 20th century but also served as the place where the signs of educational change were both real and symbolic. This pair of photographs reflects changes in Oneonta's traditional mission. Above, in 1952, the name of the institution is changed from Oneonta Normal School to State University College of Education, reflecting the college's interest in educating teachers at both elementary and secondary levels. Below, in 1962, the name is changed to State University College, reflecting the coming of the liberal arts curriculum and the emergence of the college as a multipurpose liberal arts college.

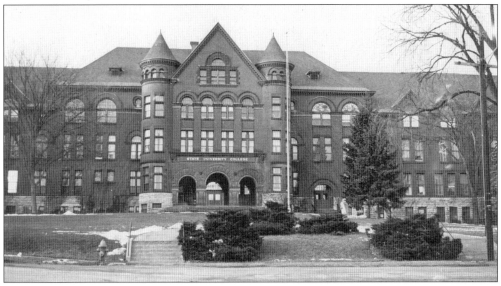

**THE SITE CHOSEN.** When word got around that the state of New York was willing to locate a normal school in Oneonta, several sites were made available. Two were considered seriously. State Supt. Andrew S. Draper rejected a site of three acres near Main Street and the present Walling Boulevard. Instead, part of a farm owned by Delos Yager was chosen. Situated at the end of Maple Street and on a hilly slope, the site required improvements, which the village was willing to provide. In this 1961 photograph, we can look down Maple Street and see the church steeples and rooftops of the downtown area. President Netzer used to step outside his Old Main office, light up his pipe, and greet students as they came up the walkways to class.

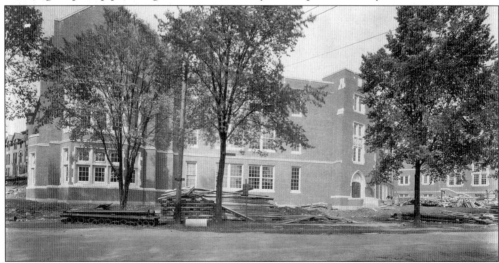

**THE PERCY I. BUGBEE SCHOOL IS BUILT.** In 1933, the normal school finally got another building; it was to be a training school for teachers. As soon as it opened, it was found to be unable to support all of the observers, participators, and student teachers who needed training. At approximately the same time, Evelyn Hodgdon was hired to develop and conduct an off-campus student teaching program. Hodgdon was primarily interested in bettering rural education by providing the best experiences—in supervised settings—for the Oneonta graduates.

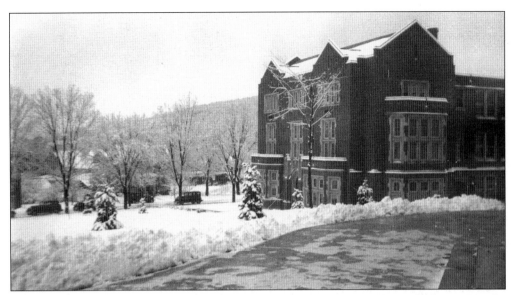

**THE BUGBEE SCHOOL IN WINTER, 1937.** Bugbee provided a regular public school program for pupils in kindergarten through eighth grade. Pupils attending frequently had as many as three people teaching them, with two in various stages of practice teaching. Bugbee-educated youngsters, upon entering the public school system, were thought of as ill-mannered, boisterous, and lacking some social graces. However, upon graduation from high school, they were frequently high achievers, creative, and more likely to be destined for higher education.

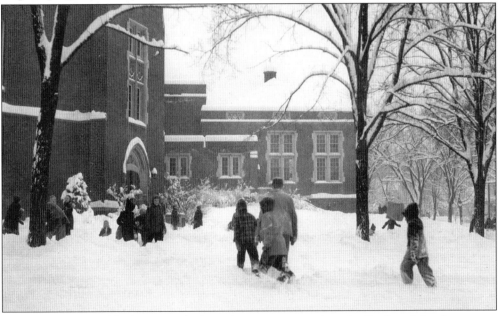

**CALLED BACK.** In 1946, the junior high grades were restored to the Bugbee School program. Campus schools were under attack by those who envied their independence and questioned their "experimental" character. Frequent field trips, science outings, and campouts were a common part of the Bugbee curriculum. While the school functioned as a public school, it was also an observation center, a laboratory to try new teaching materials, and a place for parents to learn more about their children.

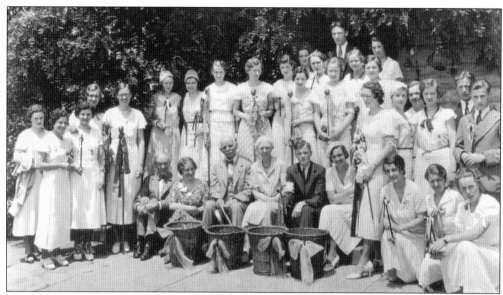

**MEETING WITH PRINCIPAL PERCY I. BUGBEE, 1933.** Initiations, Paper-Hat Assemblies, Moving-Up Days, candlelight ceremonies, recitals, and teas were all part of the normal-school learning environment. It should be remembered that many of these rituals were inexpensive, lending themselves to the building of character and a continual sense of accomplishment. Character and civic awareness were particular concerns of Principal Bugbee. He is pictured with a student class that has just been initiated, or moved up, in academic accomplishment.

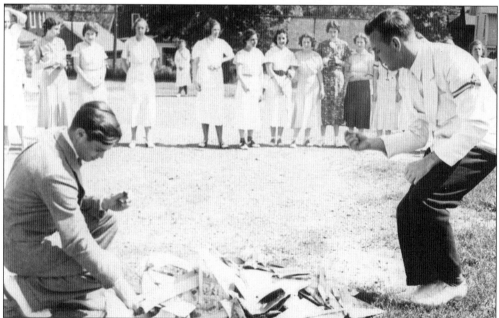

**A PAPER-HAT ASSEMBLY, THE 1930s.** The tradition of the paper hat began in the 1930s and entailed each student making a paper hat, which was supposed to last a year. At the subsequent Moving-Up Day, that paper hat was burned. Eventually, the seniors would burn their hats and don caps and gowns. This event was formalized into a pre-graduation ceremony. Some of these traditions lasted until the 1960s.

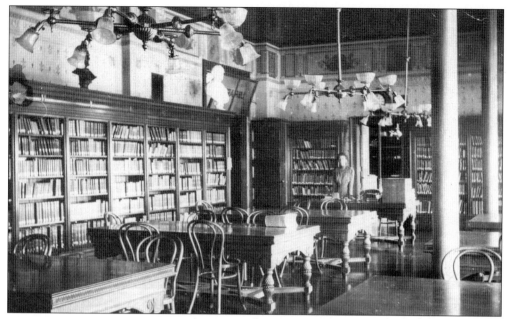

**THE LIBRARY AT OLD MAIN, 1913.** When the first Old Main was opened, it lacked furniture, books, and even a chair for its principal. Such was not the case when the opening of the second Old Main occurred. Legislative appropriations were made for books and furnishings. These book purchases were supplemented by publishers who wanted to replace their original contributions.

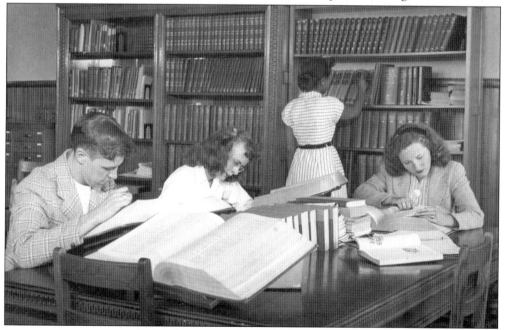

**STUDYING IN THE LIBRARY, THE 1940s.** The library remained in Old Main for more than 65 years. From a few books in 1894 (many of them contributions), the holdings had grown to more than 200,000 volumes by 1967. Plans had to be made to develop a third library facility. By 1970, a new building was under construction, and it was originally designed to hold more than a half million volumes, along with space for the new retrieval technologies.

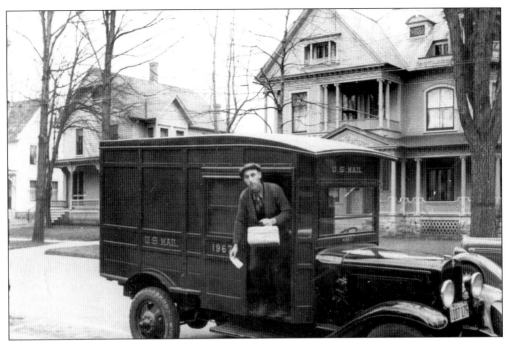

**DELIVERING THE MAIL, 1937.** Normal-school students lived throughout the community, and mail was delivered to their residences. Mailboxes in Old Main were designed for in-house communications, and it was not until the late 1940s that a complete mailroom and system was in use on the campus.

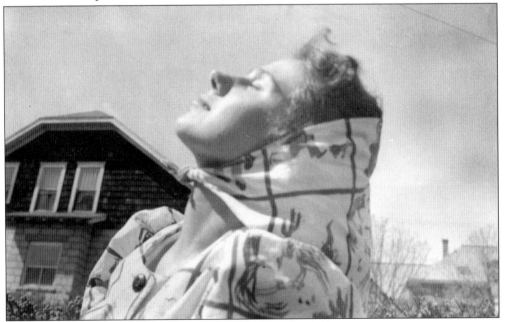

**RECEIVING THE MAIL, THE 1940s.** An unidentified student, standing in front of 95 Maple Street, strikes a pose reminiscent of just receiving a long-awaited letter from home or from a boyfriend. At this time, the ratio of females to males was nearly seven to one. Boyfriends—especially those still loyal but at home—should be kept as long as possible.

**THE HOUSE AT 95 MAPLE STREET, THE 1940s.** Oneonta Normal School did not have any dormitories. Students were housed in the neighborhoods in the vicinity of Old Main. The trolley was used by those living farther downtown. Smaller homes like the one pictured here would house four or five students who would live with the family or housemother. In this house, a male student dropped a cannonball into the bathtub to measure water displacement. The ball smashed through the bottom of the tub, and the water soaked the ceiling so badly that it collapsed on the dining room table, cracked into pieces, and broke the picture window. The repair bill was nearly $1,000 in 1950s money.

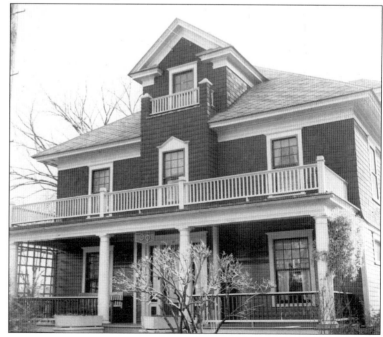

**A SORORITY HOUSE, THE 1940s.** In the absence of dormitories, many sororities leased or rented large Victorian homes in the neighborhood. Housemothers ran sorority houses according to the strict rules of the normal school. Study hours, limited nights out, and strict accounting of comings and goings were expected.

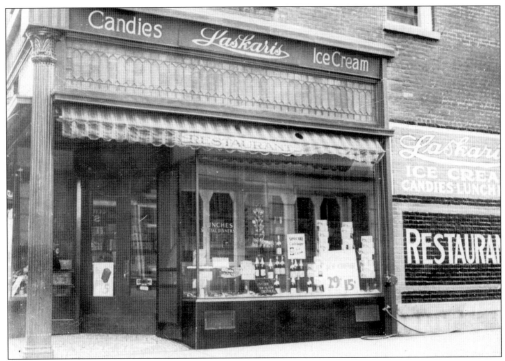

**A Favorite Gathering Spot, the 1940s.** Karmelkorn, Oyaron Rest, Bresee's, George's, Diana's, and Laskaris' were all places to dine on Main Street during the 1940s and 1950s. Several were owned by Greek members of the community. Food was both excellent and reasonably priced. They served as meeting places for both students and townspeople.

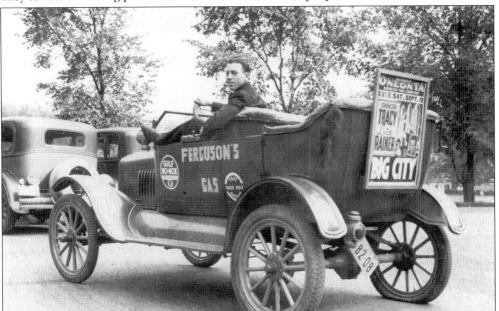

**An Advertising Opportunity, 1937.** In the depths of the Great Depression, jobs were limited, but this student entrepreneur seized the moment by providing a moving billboard for the local theater and gas company. Looking closely, one can see the coming of a flat tire in the right rear.

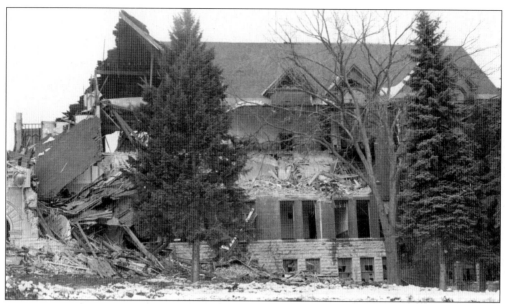

**THE PASSING OF A GIANT, 1977.** For nearly three quarters of a century, Old Main was the administrative and academic core of the college. It was the only building until 1933, when Bugbee School opened. The next building was not completed until 1954. In the 1960s, however, classroom buildings rapidly came on line, followed by dining halls, a physical education building, and an administration building. All of these were built on the upper campus. Old Main became isolated and technologically outmoded. An early-1970s alumni bulletin stated, "There is a small chance, however, that if the remodeling of 'Old Main' should prove to be too expensive, it may be demolished and a new building built on the site. At this time, this is only a remote possibility, but it could happen." Demolition is exactly what did happen. During February 1977, the building was demolished and, eventually, an apartment complex was constructed on the site. Many of Oneonta's alumni never saw Old Main, and all of their remembrances are of the upper campus.

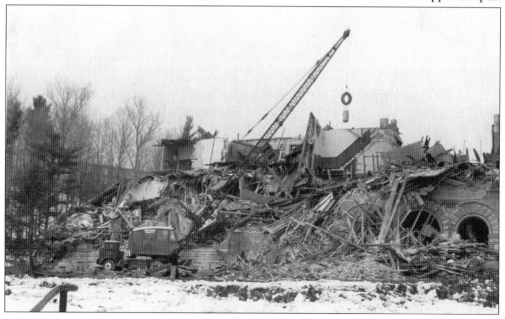

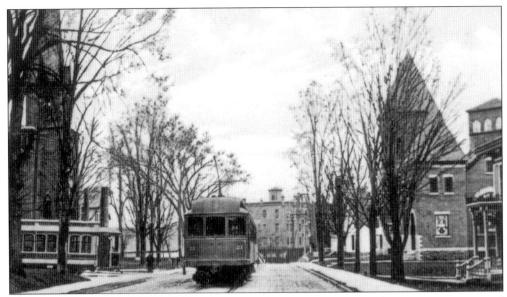

**The Trolley to Old Main.** Oneonta's trolley service would first leave Chestnut Street, proceed up Church Street, take a right at Center Street, and take a left on Maple Street to the school. Once the school was busy, Maple Street became very populated. It was first called Bronson's Lane, which went through the Bronson family farm. It went over Normal Hill and connected with a road to Laurens.

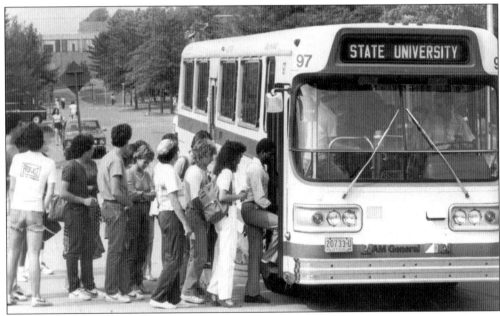

**The State University Bus (OPT), the 1980s.** In the 1980s, a contract with the Student Association led to the city providing transportation to and from downtown on a scheduled basis for all students. The hours extend from early morning (prior to the first class) to late in the evening. Additional buses are provided, based upon events or student needs.

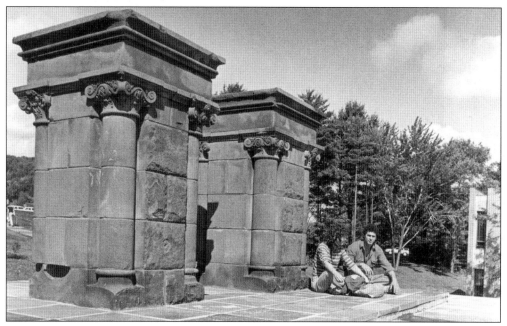

**THE OLD MAIN PILLARS SAVED, 1981.** As it became apparent that Old Main was an endangered species, people began to inquire as to what could be saved for future generations. It began to be thought of as an important link to the past. President Clifford J. Craven suggested that the center pillars be saved and placed on a prominent hill overlooking the quad. The Oneonta Alumni Association was recruited to help in a fundraising drive to reset the pillars. The site has been improved with brass tablets and benches, making it a worthy reminder of times past.

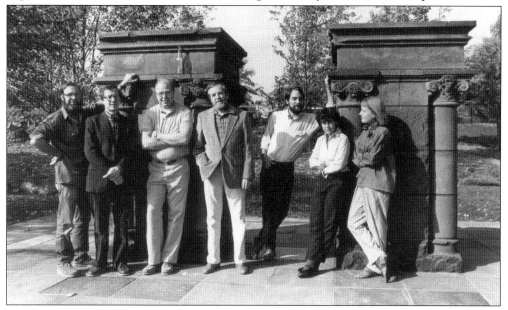

**THE PILLARS VISITED, 1985.** The pillars are a popular "dropping by" spot because of their location—midway between Hunt Union and the academic quad, near the stairway and on the way to the coffee shop. In this photograph we find most members of the art department relaxing at the site.

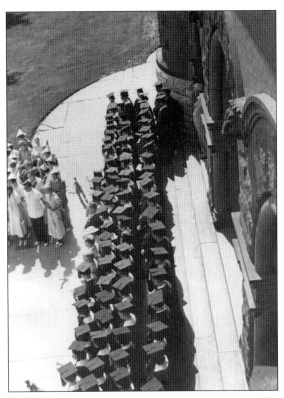

**MOVING-UP DAY, THE LATE 1930s.**
Seniors are shown lining up with caps
and gowns while underclassmen stand
by with paper hats on. Dr. Charles
Schumacher can be observed in the
doorway. It is interesting to note that
the college kept an inventory of caps
and gowns on hand for graduates to
use. Moving-Up Day was another way to
get them fitted, cleaned, and pressed
prior to commencement.

**LEARNING THE LESSONS OF OLD MAIN, THE
1940s.** While Old Main was the main
campus and the normal-school heritage
was prominent, changes were coming
rapidly. The institution became a teachers
college, granting its first four-year degrees
in 1942. Academic standards were raised
and high school prerequisites were
prescribed. Enrollment was increasing.
President Charles Hunt spoke of the need
for more land, and the Albany authorities
began to think of a postwar plan.
Glimmerings of hope for a state university
began to emerge from discussions held at
the state level. Locally, plans called for
classroom and administrative buildings
and dormitories—all up the hill on the
new upper campus. After nearly 75 years,
the lessons of Old Main were learned,
and new facilities were needed.

# *Two*

# THE ACADEMIC
# ENVIRONMENT

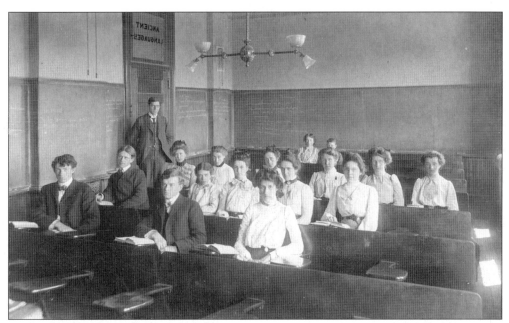

**TEACHING THE CLASSICS, 1902.** Attending the normal school *c.* 1900 meant studying the ancient languages. Here we see one of Dr. Frank Blodgett's Latin classes. Not much attention was paid to creating a "learning environment." The presentations were largely lecture, recitation, and a great deal of note taking from the chalkboard. In fact, there were times when textbooks were in short supply, and this method helped ensure that students were exposed to the same material.

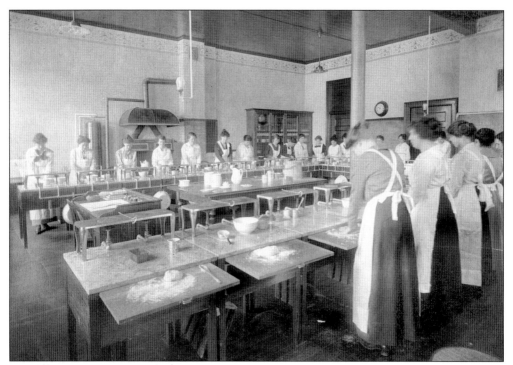

**CHANGES WERE NOT RAPID, 1896 AND 1922.** The home economics classroom stayed the same for many years. In these two photographs (taken 26 years apart), we see the same demonstrations. In 1950, a new home economics building was completed, featuring several different types of laboratories. Today, plans have been made for a complete renovation of that facility, reflecting its needs in the housing of a department of human ecology.

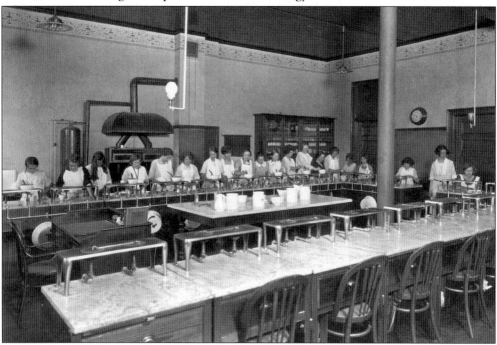

**FOUR PROMINENT FACULTY MEMBERS, 1915.**
Pictured from left to right are Dr. Charles
Schumacher, Dr. Frank T. Blodgett,
Dr. Bacchus, and Prof. Arthur M. Curtis.
Dr. Schumacher was known as a stimulating
teacher, stating that his aim in teaching
literature was to have students "understand it,
love it, and live it." Professor Curtis believed the
major objective of teaching mathematics was to
train the student to think logically and
accurately in reference to the expression
of facts.

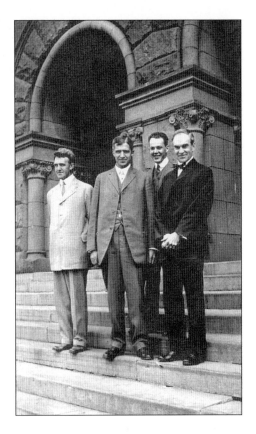

**ALBERT MILLS, PROFESSOR OF ENGLISH, 1920.**
There was hardly any workload too heavy for
Prof. Albert Mills. He would divide down the
large groups and put capable students in
charge. He would then organize and schedule
orations so he could hear them, leaving
preliminary quizzes and preparations to be
graded by the students. Displaying versatility,
Mills taught logic, history, and science of
education. A few years later, he was teaching
English, economics, and sociology.

35

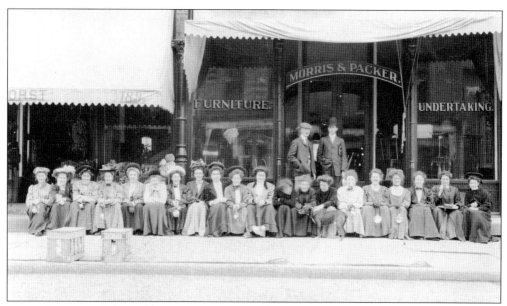

**AN EARLY FIELD TRIP, 1908.** Instruction frequently varied in the normal school. For some faculty members, teaching was reading, recitation, and recall. For others there were opportunities to get students out to other places and observe behavior of the people in their communities. Pictured is a trip to Round Top on May 23, 1908.

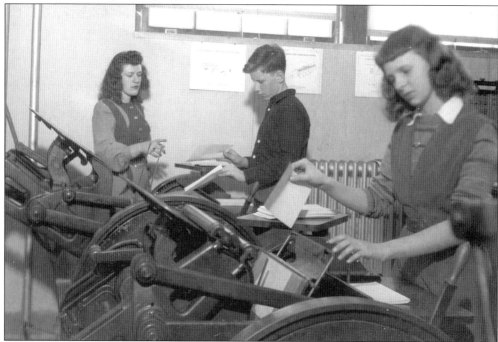

**INDUSTRIAL EDUCATION, 1903–1946.** With advancing technology diminishing its importance, manual training continued in the curriculum and included woodworking, ironworking, sewing, and cooking. From these courses, teachers were expected to be able to impart knowledge of these skills to their pupils. Some critics questioned whether those courses took away from the time to teach the traditional subjects.

**DR. ALBERT E. FITZELLE, DEAN AND HISTORIAN, 1917–1950.** Albert E. Fitzelle served in the education department, as director of training, as placement officer, and as dean of the college. He was widely known in public school circles and kept a wide range of acquaintances in the professional education field. After retiring, Fitzelle served as city historian, proclaiming that each day he clipped newspapers, strolled the streets, and answered questions from those who were tracing their family roots. "Sometimes," he chuckled, "they find relatives they would rather not have hanging from the family tree." Fitzelle understood the educating of teachers and always promoted the highest standards to measure their performance.

**RURAL EDUCATION PERSONIFIED, 1935.** Evelyn R. Hodgdon was a strong believer in rural education and off-campus student teaching experiences. Principal Percy I. Bugbee was opposed to off-campus student teacher experiences because he was convinced that they would lack quality. Dr. Charles Hunt was a believer in such experiences and hired Evelyn Hodgdon to put such a program into effect. "Hodgie," as she was affectionately known by all, designed an effective supervision program within the context of rural education. She started the community study survey series in which student teachers learned in depth about their communities. Off-campus supervisors were trained and multiple visits were planned for each student teacher. Many of the basic principles of Hodgie's original program remain today—over two thirds of a century later.

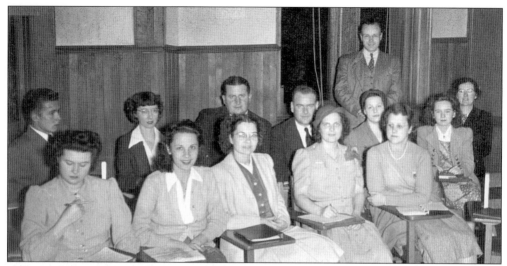

**AN EXTENSION CLASS IN SPANISH, 1942.** After the normal school was officially designated a teachers college, the demand grew for in-service training courses for teachers. President Charles Hunt generally opposed extension courses because it was difficult to ensure that they were of high quality, well attended, and graded uniformly. There was also the issue of mixing graduate and undergraduate students in the same courses, thus either diluting their rigor or making them too easy. It was during the 1950s that these problems were worked out, making more legitimate the credits and quality of extension courses.

**A PROUD TRADITION, 1894–1963.** For 69 years, there was a Curtis on the Oneonta faculty. Arthur Curtis came on board in 1898 as an instructor in mathematics. During his career, he taught several different subjects. He attended teacher institutes, spoke to professional groups, and lectured on many diverse topics. However, his major contributions were in the field of community service. He served on library boards, welfare organizations, and international relief organizations. A stern taskmaster, he was remembered as skilled, accurate, and sympathetic— after an outburst or two. E. Lewis B. Curtis, pictured here, was a social studies teacher, greatly interested that Oneonta students become exposed to the international scene. Field trips were encouraged. Curtis had taught in Turkey, attended the University of London, and observed the League of Nations for a period in Geneva, Switzerland. Lewis Curtis was a pacifist in nature and was very interested that Oneonta students realize what occurred throughout the world. He worked hard to change courses so that they reflected different cultures.

THE TOBEY HOME MANAGEMENT HOUSE, 1959. Katharine Tobey, privately wealthy, served the college in a number of roles. She taught American history, English methods, English literature, and children's literature. She served as dean of students from 1933 to 1941, retiring in 1944. Her study abroad put her in a small group of faculty who had that experience. On campus, she was a faculty member who started many traditions with student leaders, including Moving-Up Day and the Paper-Hat Assembly. Tobey left her home to the college, and it functioned as a management house for home economics and as a guesthouse for many years.

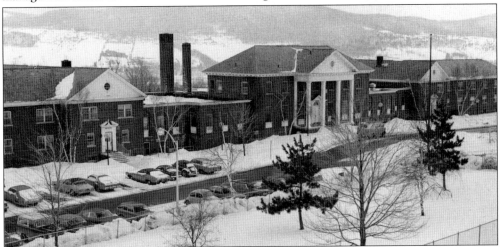

A CRITICAL NEED STARTS TO BE FILLED, 1947–1951. As the second half of the 20th century began, the need for dormitories became critical to the life of Oneonta. The Dormitory Authority approved a new two-story dormitory building in 1947, but Gov. Thomas E. Dewey withheld his approval for two more years. Finally, in May 1950, the cornerstone was laid. In February 1951, one wing was completed, but it was not until September 1951 that the entire building was operational. While this was not an auspicious beginning for the upper campus, the building complex was badly needed and was immediately put to use, providing some relief for the pressures on Old Main. The complex was given three names: Morris, Bacon, and Denison Halls, with Morris Hall being the center or conference facility and the other two being dormitories.

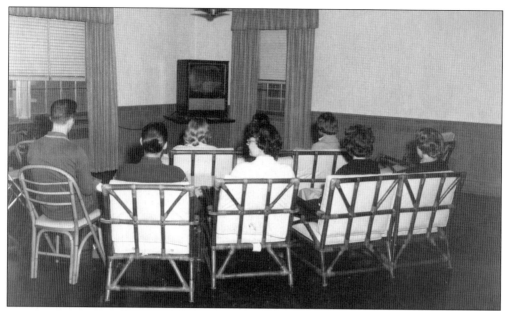

**THE NEW FACILITY, 1961.** After some initial problems, Morris Hall quickly began to be used to capacity. Saturday seminars were held in the small conference rooms, and the smaller lounges were used for relaxing, small-group entertainment, or programs. The facility has been renovated periodically, and its use is at full capacity today. In terms of providing rooms for seminars and studying, the building was badly needed.

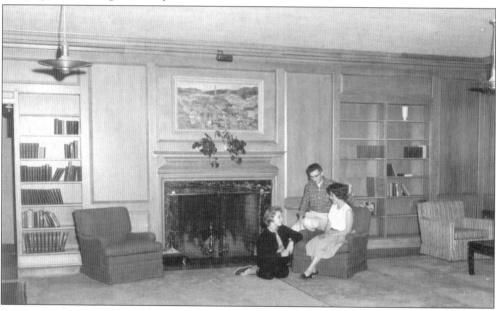

**A LOUNGE IS RENAMED, A PRESIDENT HONORED, 1987.** The center lounge in Morris Hall is one that has served as an excellent meeting room since the building was completed. The lounge has always had overstuffed chairs, ample couches, and lamps, along with new carpeting. President Clifford J. Craven had the complex renovated into a conference center. Following Craven's retirement, it was decided to rename the lounge the Dr. Clifford J. Craven Lounge in recognition of his service to Oneonta.

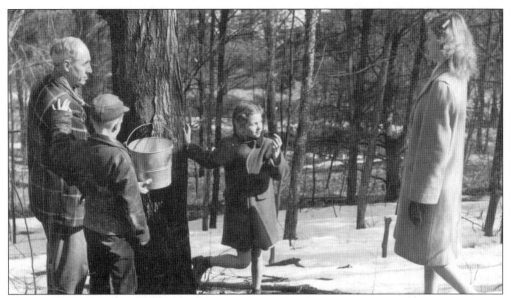

**TAPPING FOR MAPLE SYRUP, 1945.** The emphasis on outdoor science education continued into the 1940s. Dr. Robert Johnson led several community studies that were initially organized for faculty and later adapted into being part of the student teaching experience. In the summer of 1947, Dr. Johnson and others accompanied 29 students on a field trip that studied plant life, geology, local history, folk culture, and other aspects of community and outdoor life. The thrust was for students to get directly involved rather than just reading or talking about such issues.

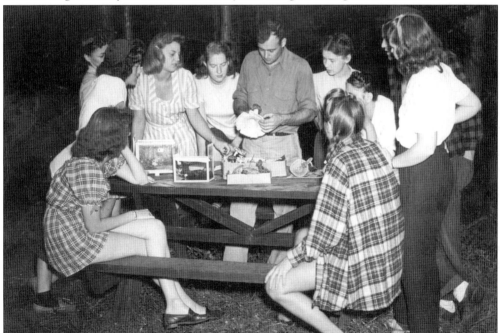

**A GENERALIST TEACHER, 1945.** In this photograph we see Milon Bundy teaching about plant life. As subject matter became more specialized and more faculty members were hired, assignments changed. When the author attended Oneonta in 1954, Bundy was teaching physical education. Later, Bundy served as the first full-time director of admissions.

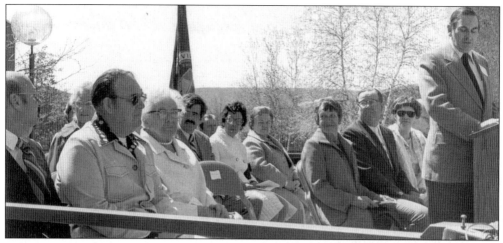

**"HODGIE" REMEMBERED, 1977.** The coming of the instructional resources center was a major event in the use of technology to make instruction more effective. A large lecture hall was available, along with audio, a rear-screen projector, and a technician to help set things up for the instructor. When it was first opened, its purpose was to aid in the improvement of instruction by the faculty. Some faculty members were reluctant to turn over their notes and outlines to instructional assistants who could make slides, transparencies, and other graphic aids, but several began to sign up to receive assistance. Instruction did improve, and Evelyn Hodgdon was fondly memorialized. While the Instructional Resources Center (IRC) was a far cry from Hodgie's rural schoolhouse, the same objective was sought—the ability to teach young people something that would help them later in life. Dr. Carey W. Brush, acting president, presided at the ceremonies, with presidents of alumni chapters as honored guests.

**THE COOPERSTOWN GRADUATE PROGRAM, 1967.** Oneonta had one of the most unique graduate programs in the nation when it offered master's degrees in American Folk Culture and History Museum Studies. The program was in cooperation with the New York State Historical Association and other state agencies. Graduates have gotten jobs in museums throughout the country, and others have become conservationists, curators, and museum administrators. In this photograph, Dr. Bruce Buckley and Larry Older get ready to participate in the sesquicentennial of Ernie Conor in Waterford, New York.

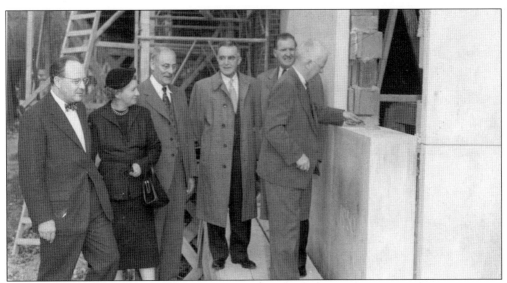

**UPPER CAMPUS PROGRESS, 1954.** The home economics building was opened in 1954 after design, construction, and budgetary problems delayed its completion. The classrooms and laboratories immediately took some pressure off Old Main and also gave faculty and administrators a much better idea of what the problems would be when instructional activities were taking place in two different locations. In this photograph we see four members of the College Council members, Dr. Netzer, and Dr. Hunt, who is applying some mortar to the cornerstone, which is dated 1950.

**THE HOME ECONOMICS BUILDING OPENS, 1954.** The home economics building was a welcome addition not only because it serviced those majors but also because other departments, particularly the sciences, could use any available space. However, the building retained the primary facilities, such as demonstration rooms, a small auditorium, exhibit cases, and lounges for home economics majors to use. Part of the reason for space availability was that the initial number of home economics majors was small. Although plans called for 50 majors, only 30 actually entered the first class. Today, with over a half century of use, this building will be extensively renovated and its life extended indefinitely.

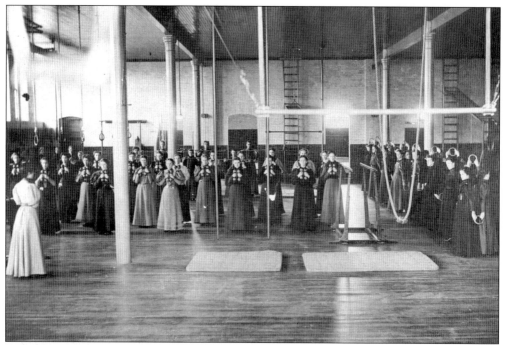

A WOMEN'S PHYSICAL EDUCATION CLASS, 1896. Physical education was important in the early normal-school curriculum. Elizabeth McLellan, an early physical education instructor, stressed "a sound mind in a sound body." During the first week, she took measurements of students and developed a program that met individual needs. At least a half hour's work was expected each day. Sometimes calisthenics were presented during chapel exercises.

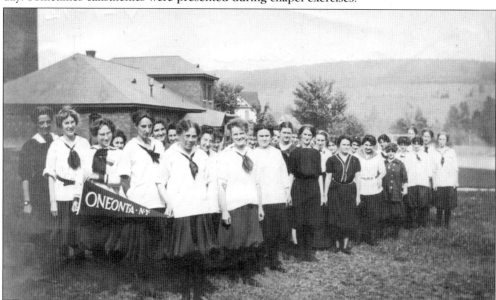

A WOMEN'S OUTDOOR GYM CLASS, 1912. The Old Main gym was limited in both capacity and design. The gym had vertical poles that were supporting that wing of the building. Many classes were held outside on the site of the Bugbee School. After the Bugbee School was finished in 1933, the women used the open area between the original heating plant and Old Main.

**FOUR TO A ROOM, 1892–1895.** Students were lodged in private homes in the vicinity of Old Main. Rules were strictly enforced by the house mothers. The normal school published detailed living regulations, especially for the women students, who were expected to adhere to strict rules regarding hours, attendance at events, dress, and other general conduct.

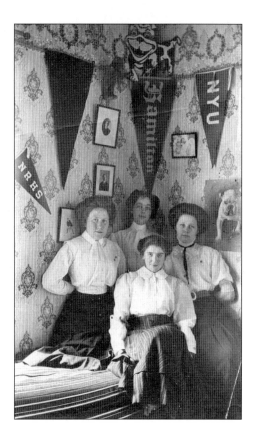

**A ROOM OR A CORNER? 1892.** Students lived in private residences, frequently sharing facilities with family members. They were allowed to put up some decorative touches. In this photograph we see early banners and pictures indicating collegiate and fashion interests.

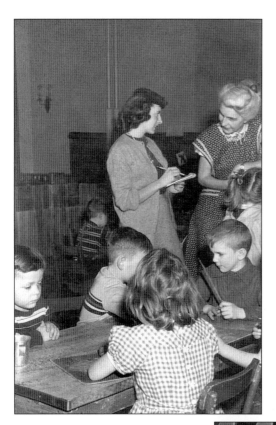

**ANNE WILCOX ANSWERS A STUDENT TEACHER'S QUESTION, THE 1950s.** Oneonta's faculty has long been known for generosity with its time. Questions are asked and answers shared. In this photograph we see Anne Wilcox taking time to answer a student teacher's question on the spot.

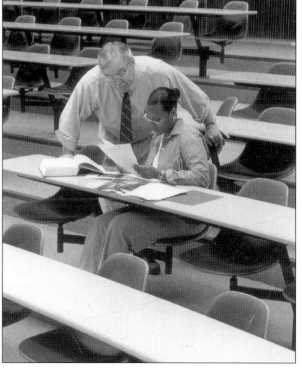

**PATRICK MEANOR ANSWERS A LITERATURE QUESTION, 2000.** In this photograph, Patrick Meanor, distinguished professor, gives an explanation to a student on a one-on-one basis. Meanor is an author of several books and yet is primarily interested in teaching, especially teaching literature to interested students. (Courtesy of the 2001 admissions bulletin.)

EARLY ONEONTA BENEFACTORS. In this photograph we see Anne Scott (geography instructor), Eulah Dodd (home economics), and Caroline Jenkins (art teacher), all faculty members who were interested in the future of Oneonta and its students. Scott-Jenkins loans and scholarships—all derived from a bequest—have provided a great deal of help to deserving minority students and those enrolled in the Educational Opportunity Program (EOP).

DR. CHARLES SCHUMACHER, A CAMPUS ICON, 1894–1938. For many years, Charles Schumacher was the only faculty member with an earned doctorate. He was one of the earliest teachers to bring variety in his instructional techniques. He taught by dictation, oral reading, the drawing of pictures, and having students write different endings to the literary works being studied. Schumacher also reported that the library holdings were completely lacking. During his long Oneonta career, he taught history, psychology, history of education, rhetoric, literature, and physical culture. He was demanding in how he taught, but many said they learned more from him than any other faculty member. He maintained many contacts with alumni long after he retired.

47

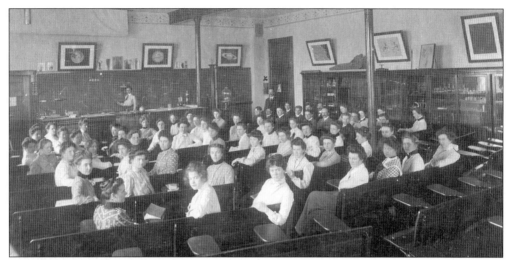

**HOWARD LYON, INNOVATOR, 1905–1906.** Prof. Howard Lyon used a full variety of instructional techniques, ranging from lecture to field trips, demonstrations, the building of homemade apparatus, and the reorganization of the laboratories in mineralogy and physics. He made extensive use of specimens—both alive and dead—and opened new experiences for beginning teachers. In planning field trips, he made them as interesting as possible, including many places of local interest—the Vlei, numerous lakes, Round Top, and an electricity-producing plant.

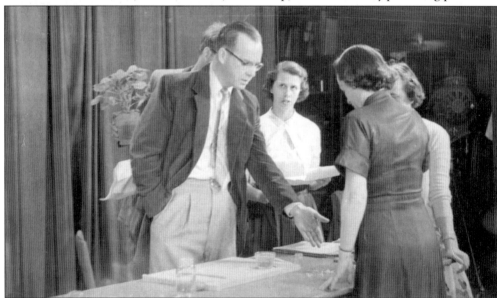

**DR. EMERY L. WILL PREPARES FOR TELEVISION, THE 1950s.** Dr. Emery L. Will guided the growth of the Sciences Division and its subsequent split into five departments. Will was an excellent facilities planner. He also played a major role in hiring many outstanding faculty members. Later in his career, he served as director of Academic Advisement, developing several innovative publications and programs. His advisement procedures won national recognition, but more importantly his attention to detail led the way for extensive computerization of student data. From his detailed planning for a Schenectady-based television program to his retirement in 1984, Will set an outstanding example as a faculty member who was careful in his planning and concerned about the academic welfare of students.

**ONEONTA SOLVES A HOUSING PROBLEM, 1946.** President Charles Hunt announced in 1944 that a limited two-dormitory complex would be built on what would become the upper campus. Complications delayed construction until 1950. In the meantime, enrollment increased rapidly and a housing shortage became a crucial problem. Hunt approved acquiring some private houses if they came on the market. In 1947, the Bugbee Foundation purchased 62 Elm Street, renovating it and a carriage house on the same property. It was named Alumni House and housed 55 students. In 1949, the Bugbee Foundation acquired 59 Elm Street and named it Anniversary House; it housed 15 students. While these buildings provided excellent housing, their use foretold of the need for better housing for all students. The need for dormitories soon became critical, and the 1960s became a decade when that need was met.

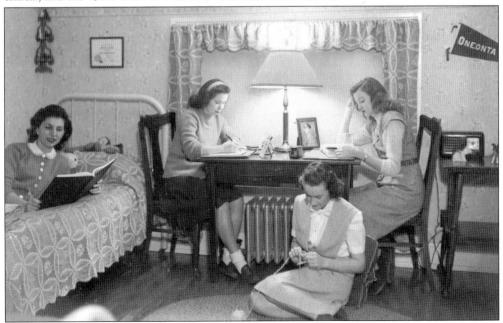

**PROFESSOR CURTIS, OUTSIDE THE CLASSROOM, 1946 AND 1953.** E. Lewis B. Curtis was a man of ideas and passion. One of his primary concerns was that Oneonta students not remain isolated. As early as 1934, Curtis was having political candidates speak to students and, a few years later, he was organizing trips to Europe for students. While he was generally interested in these broadening experiences, he was much more concerned about such causes as amnesty, peace, justice, improving international relations, and how to better the lot of mankind after the war. When Curtis directed the 1945 and 1946 summer sessions, they had courses in non-Western cultures, a travel course, and instructors from other countries. Strong Chinese, Indian, and Middle Eastern influences were also present. After retiring, Curtis taught several more years in southern Alabama, where he, undoubtedly, continued to push for greater world understanding and tolerance for all people. In the photograph above, Agnes Nelson (left), E. Lewis B. Curtis (center), and Dorothy Harris are discussing various war relief programs. The photograph below shows one of Curtis's classes on March 17, 1953, visiting with Gov. Thomas E. Dewey in the executive chambers in Albany.

**A Tale of Two Presidents, 1960 and 1995.** In the photograph above, we see Dr. Royal F. Netzer talking with students as they carry books from the Old Main Library to the first Milne Library on the upper campus. On this day in 1960, the transfer was made to the new James M. Milne Library, which opened with a capacity of 125,000 volumes. In 1962, it had 70,000 volumes, and the college was criticized by Middle States and NCATE for not having at least 110,000 volumes available. It was not long before it was apparent that a new library would be needed—one that not only housed materials, but also had designed-in capacity for the new informational technology that was more apparent every day. On June 24, 1974, the new Milne Library opened, with nearly 300,000 volumes and an annual growth rate of approximately 17,000 volumes. The staff embraced technology, along with the acquisition of the latest information-retrieval systems. The photograph below shows President Donovan attending a MultiLis reception in 1995. The adoption of this program and other software not only replaced the card catalog, it also established a state-of-the-art online catalog. Oneonta's holdings are also entered on the national database. By the 1980s, Oneonta had the second-largest collection in the SUNY system.

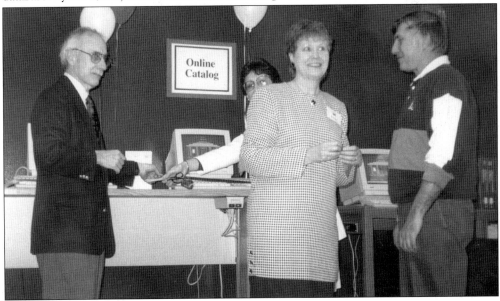

Still Life w. Fawn Scull for the Year 2500

JAMES M. MULLEN

BRUNO LABATE
1883-1963
MUSIC FOR
OBOE and PIANO
RENÉ PRINS
oboe
WALTER WOOLMAN
piano

IROQUOIS
LAND CLAIMS
Christopher
Vecsey
and
William A.
Starna

TERRORISTS
OR
FREEDOM
FIGHTERS
by
Ely Tavin
Yonah Alexander

Adelaide Crapsey
by Susan Sutton Smith

Psychological
Research
The Inside Story
Edited by
Michael H. Siegel
H. Philip Zeigler

CONDOR and
HUMMINGBIRD
A NOVEL BY
Charlotte
Méndez

MG: THE SPORTS CAR
AMERICA LOVED FIRST
RICHARD L KNUDSON

THE
CIRCL
VILLA
POEMS

Richard

BACON'S
NEW GERMAN
COURSE
by
Edward F. Bacon
Ph.3

James Preston
Mother
Worship

On the
Nature of Music
by
Hewitt
Pantaleoni

GEOLOGY
OF SELECTED
NATIONAL PARKS
AND MONUMENTS
P. JAY FLEISHER

ROBERT B. CARSON
MAIN LINE
TO OBLIVION

THE MIRACLE
of LIFE
by
Charles A.
Shumacher

Demetrios
Basdekis
UNAMUNO
AND
THE NOVEL
31
Estudios De
Hispanófila

52

**WORKS OF THE FACULTY, 1989.** Oneonta's faculty has always been known for its energetic approach to providing students with the best educational experience possible. When Oneonta was primarily a teacher-training institution, the latest approaches to effective teaching were used, including planned study tours, supervised student-teaching, increased observations and visits by college supervisors, and the idea of cooperating with off-campus centers and public schools. With the beginning of the liberal arts curriculum in 1962, the faculty began to take on a more diverse look. Asian and European faculty members brought new viewpoints and different perspectives to their colleagues and students. Scholarly work was no longer confined to articles or books. Art works, novels, poems, and original music pieces brought national recognition to the faculty. As the college completes its first century and faces a new and exciting one, the faculty remains dedicated and productive. Recent years have seen many of the faculty involved in the latest research technologies, and it is expected that these efforts will continue to contribute to improving teaching and scholarly research. (Drawing by Alberta Hutchinson.)

53

**JOHN C. KOTZ, CHEMISTRY FOR THE NEW CENTURY, 1996.** Jack Kotz epitomizes the new scientist-teacher, especially in the areas of using the most advanced technology to teach college-level chemistry. He is able to combine teaching students to get the most out of their computers with the teaching of inorganic and organometallic chemistry. He is the author of a CD-ROM and two well-received college textbooks. While he is constantly involved in research and writing, he still teaches basic courses and enjoys interacting with his students. (Courtesy of College at Oneonta Public Relations Office.)

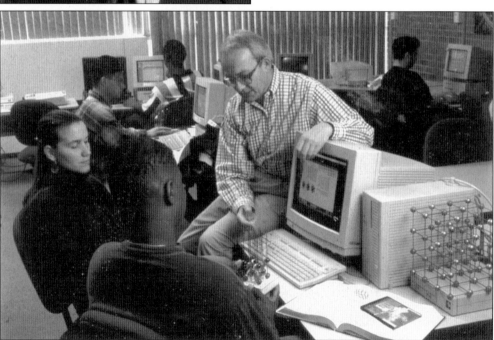

**THE COMPUTER AND CHEMICAL COMBINATIONS.** Dr. Kotz explains the chemical makeup of a compound by the use of both the computer and structural approaches. (Courtesy of Creative Communications of America; photograph by Paul Talley, 1996.)

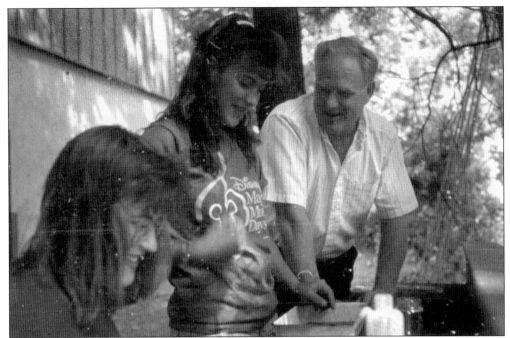

**DR. WILLARD N. HARMAN AND THE OTSEGO LAKE CHALLENGE.** Willard N. Harman is known for his enthusiasm and interest in both protecting our environment, particularly water, and teaching students. He is particularly knowledgeable in ecological topics—aquatic, terrestrial, and limnological—and how they relate to the management of Otsego Lake, Cooperstown, New York. Harman is the director of the Biological Field Station, providing many research opportunities for both graduate and undergraduate students. (Courtesy of College at Oneonta slide collection.)

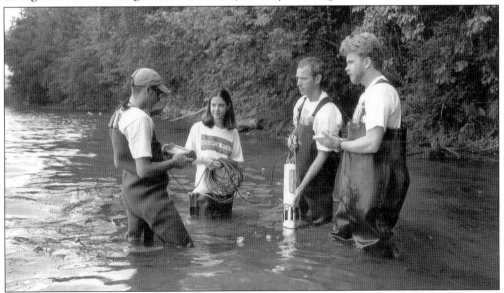

**A HANDS-ON OPPORTUNITY.** A research team starts some preliminary work as it begins to set up and use some Hydrolab equipment. Students spend a great deal of time studying Otsego Lake to determine water quality, the presence (or absence) of zebra mussels, and harmful influences such as mirafoil and runoff. (Courtesy of College at Oneonta Public Relations Office.)

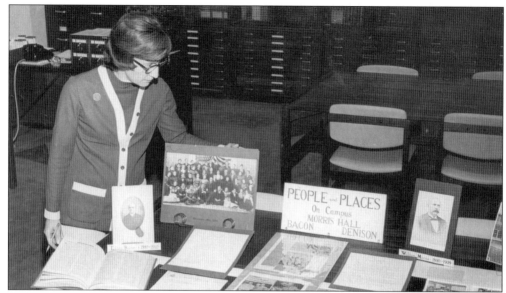

**PRESERVING OUR PAST: MARTHA CHAMBERS REMEMBERED, THE MID-1970S.** A special feature of the new James M. Milne Library was the Alden Room, which housed the archives and special collections. More importantly, it had Martha Chambers, who made preserving the past fun with her competence, grace, and enthusiasm. She produced special programs and encouraged the faculty to be speakers or invite outside guests to participate. When there were special events, she would frequently produce or write pamphlets that memorialized the event or people who were to be remembered. For example, she produced "The Past as Present: The Story of Campus Dedications," a pamphlet describing the development of the upper campus on a building-by-building basis, along with how the individual buildings were named. She also made the special holdings available to students. Martha Chambers passed away in 1986. She was greatly appreciated by all who worked with her. She set the standard for preserving our past, and those who follow are working to continue the quality of what she did.

# *Three*

# STUDENT LIFE
# AND ORGANIZATIONS

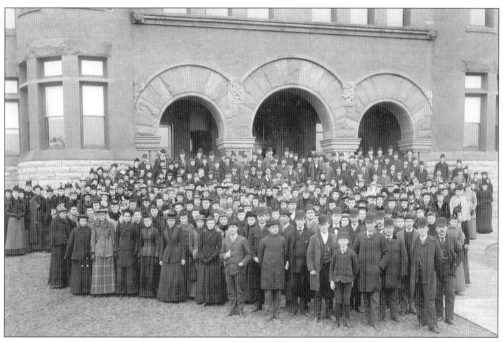

THE STUDENT BODY, 1892–1893. In his definitive history of the College at Oneonta, Dr. Carey W. Brush wrote, "Facilities and faculty alone do not make an educational institution. The third necessary component is a student body." While some students were not interested in teaching, the institution existed primarily for "worthy and aspiring young men and women who desire to prepare themselves for teaching." In this photograph we see the entire student body and several faculty members, most notably Prof. Edwin Faxon Bacon, who is standing in the front row at the extreme right in a derby hat.

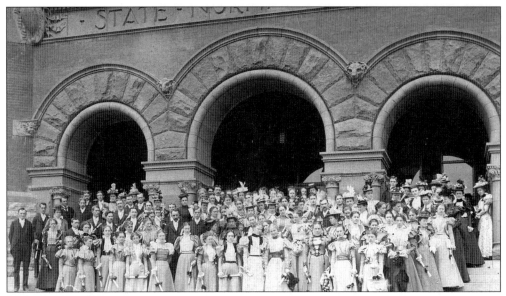

**THE GRADUATING CLASS OF 1897.** One of the largest graduating classes in Oneonta's early history, the 1897 class numbered 142. The opening of a new normal school on Long Island attracted many potential Oneonta students. In 1897, Oneonta's graduating class was second only to Geneseo in size. By 1900, it dropped to sixth place among the normal schools, according to Oneonta's annual report of 1898 (filed with the state superintendent of instruction and quoted by Dr. Carey W. Brush in *In Honor and Good Faith*). An interesting observation that identifies Old Main as the "new" building is that the inscription "State Normal School" is just above the arches, while the original had the designation up near the third-floor windows.

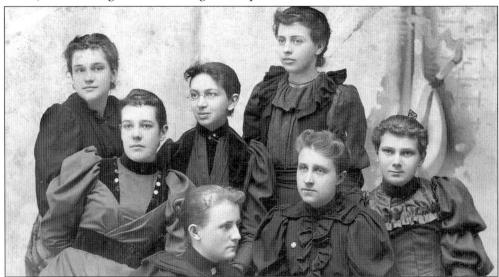

**EARLY STUDENT LIFE, 1894.** In the early years, all student housing was in private homes. Organizations began to develop in the housing accommodations, which were usually located in close proximity to Old Main. While most homes had one or two rooms to rent, there were instances where groups of five or six were able to be housed together. This picture shows a group of seven women who lived at 15 Cedar Street and called themselves the "Normals." Cohesive groups began to request group housing, club rooms, and other facilities as they developed various interests.

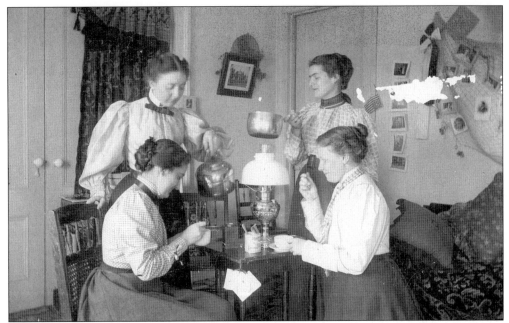

**FUDGE AND TEA, 1898.** Students congregated in their rooms for many small social events. Sometimes these informal teas prepared them for the more formal faculty-student affairs that they were expected to attend. Problems with student behavior were nonexistent except for occasional untidiness. Rules required students to be in class or study hall. Attendance was strict and sickness was the only accepted excuse, if the school was in session. Whispering without permission could cause a loss of privileges.

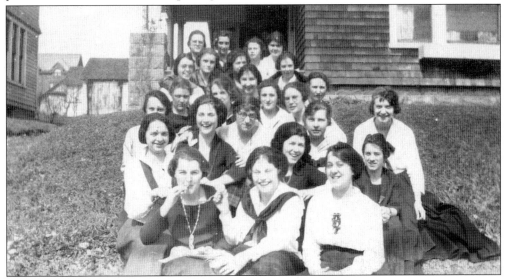

**A CLUB IS FORMED, 1920–1921.** Housing in private homes persisted in the early 20th century, but changes began to appear as more students wanted to live in group housing. Housemothers and cooks were employed, as students began to occupy nearly an entire dwelling. In this picture we see a group of women students who called themselves the Davis Club, named after their cook. Two girls planned the meals for the week and figured the cost. Each girl paid a share, ranging from $4 to $7 per week. Rooms were $3 per week, with two students per room.

A NEED IS MET, 1895–1898. The need for organizations in the normal-school setting manifested itself in several ways. After the disastrous fire that destroyed the original Old Main, a hose company was formed of 27 members. The Local Board purchased a cart, reel, hose, and other apparatus, costing about $400. When the company applied to the village board of trustees for admittance to the fire department, some companies expressed opposition because they felt they would be at a disadvantage in local athletic contests. However, the trustees approved the company's admission, citing it as additional fire protection. In April 1896, the company became part of the village fire department and was named the James M. Milne Hose Company.

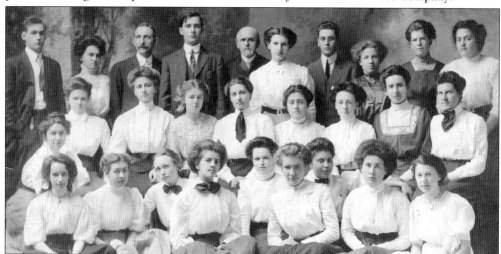

PROF. EDWIN FAXON BACON'S HERMANIA, 1893. Of all the faculty who served the normal school initially, the most beloved was Edwin "Daddy" Bacon. Under his leadership, Oneonta was the first to offer work in modern foreign languages. An author of several books, he was always experimenting with ways to teach languages. Some of his methods are popular today. His greatest love was the German-language club Hermania, which met on a fortnightly basis and published a monthly newsletter in German. It is rumored that he never missed one of its 220 meetings. Bacon wrote plays for Hermania members to perform at commencement exercises. He was known for helping the less fortunate, including needy students. As an organization, Hermania prospered when Professor Bacon was involved. Upon his passing in 1911, it disbanded.

CLIONIAN: AMONG THE FIRST LITERARY ORGANIZATIONS, 1889 AND 1912. Much of the extracurricular life of the students centered around membership in the literary societies, which were ancestors of the present sororities and fraternities. They met on a regular basis, frequently choosing a particular theme for a semester's study and presenting a debate, musical, drama, or some other sort of public program at the end of the semester. Most had a glee club or instrumental group that also performed. This photograph shows the society in 1912.

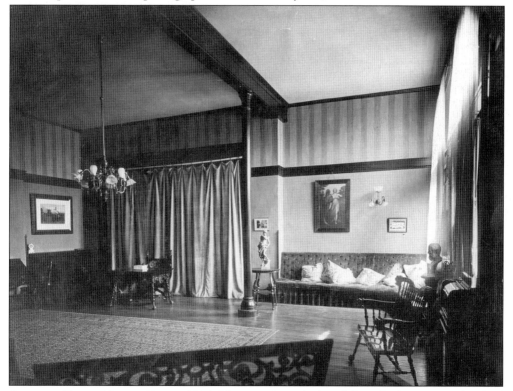

CLIONIANS HAVE A MEETING PLACE, 1932. These societies had well-furnished rooms on the third and fourth floors of Old Main. In addition to rugs, drapes, and comfortable furniture, most of the rooms had pianos that the societies had purchased. Often, societies would join together for social events.

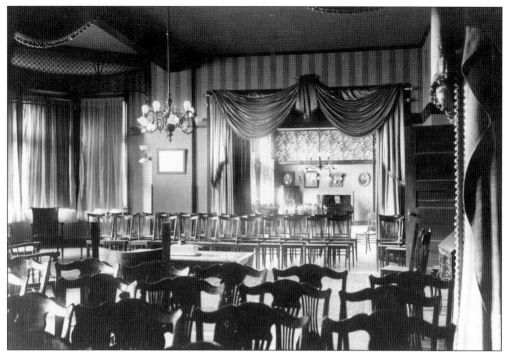

**USE OF A JOINT FACILITY, 1932.** While the Clionian and Delphic societies had different purposes initially (the latter being a debating club), they frequently collaborated on their public programs. At the 1890 commencement week exercises, these two societies made a joint presentation. This photograph shows the joint club rooms that they used for formal meetings, rehearsals, and social events.

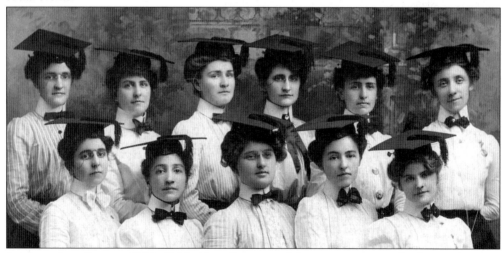

**SOCIETIES JOIN FORCES, 1901–1908.** After the successful presentations made during the 1890 commencement week by Clionian and Delphic societies, other alliances were formed. Rather than merely add organizations, it was decided that societies would be more effective if they banded together. Arethusa, pictured here, joined the Clionian-Delphic group while Alpha Delta, Agonian, and Philalethean formed the other "union" groups. Thus, the planning for commencement week events was spread across three societies, and each group was responsible for a program every other year.

**THE INTERCLASS COUNCIL, 1931–1932.** Organized at about the same time as the Student League (the precursor to representative student government and the current Student Association), the council had the benefit of the leadership of Katharine Tobey, who displayed an understanding of student needs and the direction of future social activities. For example, the Interclass Council recognized voids where students were ignored who had made significant contributions to the vitality of campus life. In the 1960s, the council promoted the concept of awarding students who served in several cocurricular activities while maintaining a good scholastic average.

**THE STUDENT LEAGUE RECOGNIZES FRESHMEN, 1932.** In the spring of 1924, the Student League appointed a committee to make rules concerning freshman behavior. Each freshman had to wear a button with class numerals. Freshmen had to use different stairways than upper classmen and also had fewer privileges, such as late hours and dating. To help freshmen adjust to school life, a "big sister" system was adopted. In this photograph are six committee members, who helped freshmen during orientation week, took them on guided tours of the campus and community, and introduced them at social gatherings.

**THE STUDENT LEAGUE INSTITUTES DUES, 1924–1925.** In a time when room rates were $2 to $3 per week and board averaged $7.50 per week, students earned 25¢ per hour for babysitting and 30¢ to 35¢ per hour for other work. Some students "contracted" by working 21 hours per week for board and 7 hours for room rent. The Student League fee was $4 per semester and reached a high of $18 by the 1934–1935 period, leveling off at $15 for the rest of the 1930s. The Student League was concerned that students had good housing conditions and observed proper rules of etiquette while keeping themselves safe. The league, through its committees, followed up on student complaints. It also helped point out the need that students had to borrow money from time to time. In 1923, upon the occasion of Principal Bugbee's 25th year of service, the alumni established the Bugbee Foundation in his honor with an initial bequest of $10,305.27.

**INVOLVEMENT BY CLASS, 1932.** As the societies evolved into fraternities and sororities, there was general concern that they were controlling or monopolizing the social agenda. More emphasis was placed on casual activities, such as outings, informal gatherings, and activities by class. The Student League tended to encourage class activities. This photograph shows a freshman initiation activity held outside 56 Maple Street.

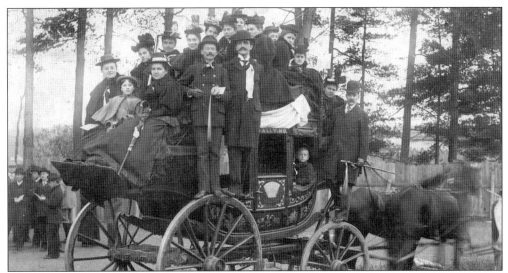

**ABOARD THE TALLY-HO, 1897.** An organization with a long history is the Outing Club. Evolving from informal outings, usually with faculty, the Outing Club concentrated on taking advantage of the outdoors, along with inexpensive activities or trips. In this picture we have a shared experience; it is doubtful that the coach hauled as many people as there are posing on it. The picture was owned by Prof. Arthur M. Curtis and was given to the college in July 1967 by his son E. Lewis B. Curtis, longtime social studies faculty member.

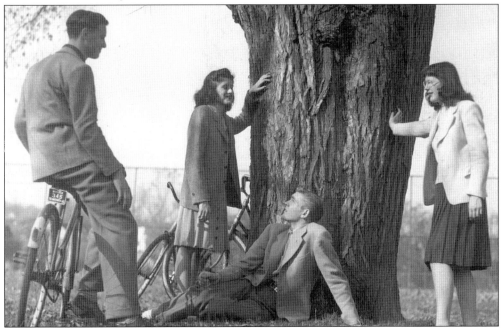

**ABOARD THEIR BIKES, 1945.** The Outing Club flourished because its premise was simple (enjoy the outdoors and respect the environment) and used only the transportation means necessary to accomplish those objectives. Today, the club uses canoes, kayaks, repelling gear, backpacks, and hiking gear. In this picture, it is interesting to note that the bicycle has an Oneonta license tag, numbered 345; it probably indicates that the bike was owned by the college. The Outing Club— through the Student Association—now owns a great deal of the equipment used in their excursions.

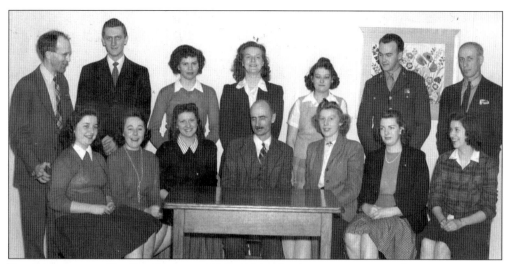

THE INFLUENCE OF *THE PEN-DRAGON*, 1900–1954. The literary magazine *The Pen-Dragon* was published one to three times a year from *c.* 1900 to 1954. It usually contained 8 to 10 essays or stories (each limited to 800 words) and a few poems. Throughout the 1930s and 1940s, there were editorials criticizing parking, advocating free speech, condemning teachers' loyalty oaths, and lamenting cheating on examinations or seeing others doing it and not reporting it. The magazine frequently printed essays that took strong positions on various social issues. In this 1942 photograph, E. Lewis B. Curtis is standing at the extreme left. Standing next to him is Dr. Robert MacVittie, who served as president of Geneseo State for many years and returned to Oneonta as alumni director in 1979. At the far right, standing, is Dr. Robert Johnson, who led several travel courses during the 1930s.

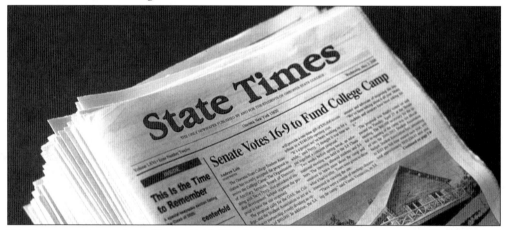

THE EMERGENCE OF THE *STATE TIMES*, 1945. The first issue of the *State Times* appeared on March 7, 1945. It quickly became the voice of the students. During the protests of the 1960s, the paper ran numerous articles and editorials opposing the war in Vietnam. There were instances when observers felt that the *State Times* stimulated students to action or calmed them down. In the area of racial conflict, the *State Times* was quick to condemn activities that had the potential for racism. While it tended to be on the left side of the political spectrum, it had several students who styled themselves as conservatives, serving as editors and writers. The *State Times* remains the primary source of news about students, with emphases on student government, Greek news, and athletics—both men and women. While it has a faculty advisor, the publication of the paper has generally been left in the hands of the student staff. (Courtesy of College at Oneonta slide collection.)

**DR. CLIFFORD J. CRAVEN, FIFTH PRESIDENT, 1970–1987.** In addition to general academic interests, Dr. Clifford J. Craven had a background in student personnel, having served as dean of students in the early 1950s. He was particularly sensitive to student needs, such as housing, finances, availability of academic program choices, high-quality advisement and counseling, along with a desire for students to have as broad a range of experiences as possible. As president, he strengthened the Oneonta Alumni Association, reinforced and promoted the activities of the College Foundation, increased the numbers of scholarships, ordered new rules for student residence halls, and promoted many other activities to enhance student life. He had a personal interest in international relations and cultural exchanges and frequently spoke to these issues in academic settings.

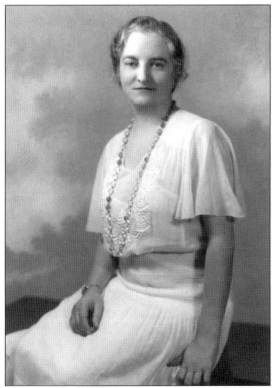

**KATHARINE TOBEY, DEAN OF STUDENTS, 1935–1944.** In addition to serving as dean of students, Katharine Tobey taught English and American history from 1908 to 1944. She had a wide range of academic interests, including English literature and children's literature. During the "age of the lecture," she would frequently have students demonstrate clothes and habits of the Colonial times, prepare skits, give reports, and otherwise become more involved than listening to lectures. She used many of these techniques to encourage student interest, in a time of scarce resources. During a time when she could have been only a disciplinarian, she elected to provide positive leadership in developing class activities, establishing standards for student housing, envisioning the need for student government, and developing student life traditions—some of which exist today. Most notable among these activities were Moving-Up Day and the Paper-Hat Assembly.

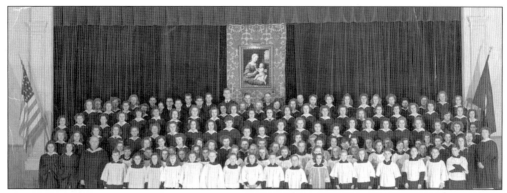

**CHRISTMAS REMEMBERED, 1943.** During the first 75 years of Oneonta's existence, there was a strong sense that the institution should celebrate Christmas by having a series of Christmas programs, usually highlighted by a large, well-attended choral or dramatic presentation in Alumni Hall of Old Main. This photograph shows the 1943 group posing prior to the program. The picture hanging in the center was borrowed from St. James Episcopal Church downtown for the occasion.

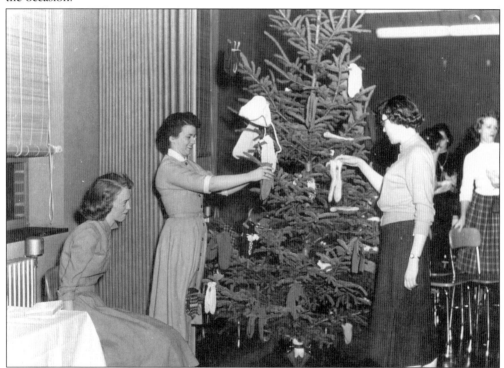

**HOLIDAYS SHARED: THE MITTEN TREE, 1955.** As the faculty and student body became diversified from *c.* 1965 onward, the holiday celebrations also became diverse and sponsored by clubs, dormitories, downtown groups, and multicultural groups on campus. Gone were the vestiges of an institution-sponsored observance. In its place, many groups developed celebrations that "gave something back," especially to the needy. In this image, the Home Economics Club is decorating their Mitten Tree in preparation for giving gifts to youngsters in the community. The 1985 *Oneontan* describes the "winter wondermen" as a group that entertained during the holidays, raised money, and contributed it to Head Start and Aid to Battered Women. Sigma Tau Alpha, a fraternity, had a singing group that entertained at hospitals and nursing homes.

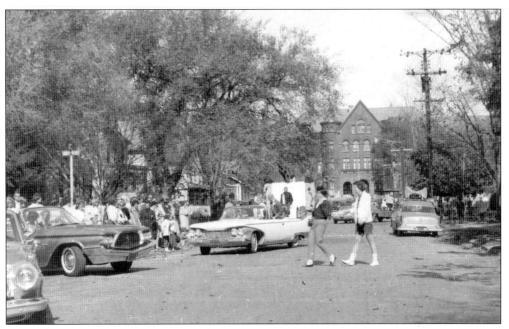

**Homecoming Parade, 1963.** Prior to the building of the dormitories on the upper campus, assemblies, parades, and rallies were held near Old Main on upper Maple Street. Residents mixed freely with students as they readied floats, wagons, and other vehicles for the parade, which was competitive regarding awards, prizes, and other recognition.

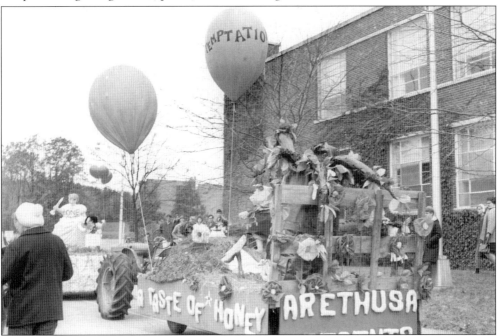

**Arethusa Prevails, 1969–1970.** As the dormitories developed, esprit de corps feelings on a hall or dorm basis began to rival the fraternities and sororities. Dormitories produced programs and participated in parades and other competitions on a dorm basis. In this instance, the Arethusa sorority prevails again, taking first place in the 1969 homecoming parade.

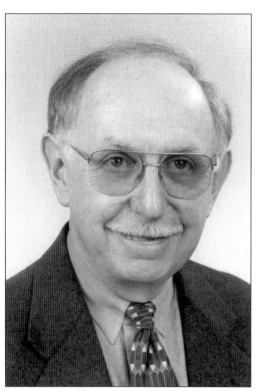

**F. Daniel Larkin: Helping to Position the College for the Next Century, 1964–2001.** Provost and professor of history F. Daniel Larkin brings a plethora of background, experience, and ability to his job as chief academic officer of the college. He earned a Ph.D. in American history from SUNY at Albany, New York, in 1976. During his long tenure at Oneonta, he has earned the highest academic rank, that of SUNY Distinguished Service Professor. His academic interests are early New York State transportation systems, notably canals and railroads. Provost Larkin has shown an excellent ability to balance competing interests and to remain focused on consolidating the gains the college has made in the last quarter century. (Courtesy of College at Oneonta Public Relations Office.)

**Ashok K. Malhotra, Helping International Relations, 1970–2001.** Dr. Malhotra's entire adult life has been spent teaching and encouraging others to understand what globalism and interculturalism are all about. His efforts extend beyond his academic discipline of philosophy. Tireless in his research and efforts to extend international understanding, he has earned numerous awards, including SUNY Chancellor's Award for Excellence in Teaching, a Distinguished Alumni Award from the East-West Center, and the attainment of the SUNY Distinguished Teaching Professorship. Following the loss of his wife, Nina, he founded the Ninash Foundation, a nonprofit philanthropic corporation that was instrumental, with Dr. Malhotra's leadership, in founding the Indo-International School in Dundlod, India. (Courtesy of College at Oneonta Public Relations Office.)

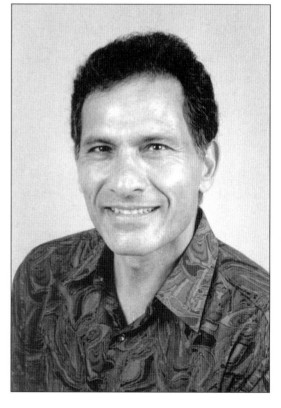

70

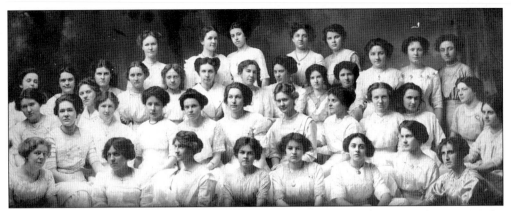

**Alpha Delta Beta: One of the Earliest Sororities, 1895 and 1950.** While starting as a club for young ladies, this group was the first to call itself a sorority. Maintaining their membership at 50, they have been known as a "helping" sorority. They sponsor an effort called Community Help Week, with proceeds going to worthy causes. Other yearbooks reported that the sorority held cake and cookie sales, a candy sale, and adopted an orphan. They also had a singing group that entertained shut-ins and performed during the holidays. Shown above is the membership of 1912, and below is the 1950 group.

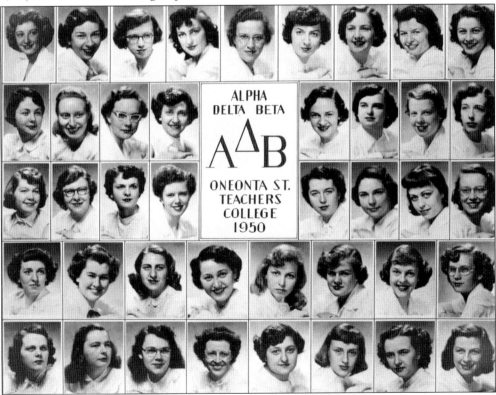

**A WOMEN'S SERVICE SORORITY STARTS, 1966–1968.** Gamma Sigma Sigma, the National Service Sorority, was formed in 1966. Sisters sent packages to soldiers in Vietnam. Other projects included helping Alpha Psi Omega, the men's service fraternity, with joint projects. The sisters have held car washes, popcorn sales, blood drives, and food drives. They have also aided in community clean-ups and arranged for visitors from Camp Brace to use campus facilities. The sisters are shown in a preliminary consultation with their advisor, Margaret Baughman. Baughman was a guiding force and positive influence for students as they occupied dormitories, moved to the upper campus, and faced a new array of governance organizations.

**THE INTERCLASS COUNCIL, 1971–1972.** As the college rapidly expanded its enrollment in the 1960s and additional dormitories came on line every year, it became necessary to recruit student resident assistants (RAs), establish new rules for dormitories (especially as they became coeducational), provide for student safety, and continually revise housing policies as students moved back to campus. These changes meant that students were relied upon more and more to develop and supervise student activities. While this council worked maintaining such class activities as the Paper-Hat Assembly, homecoming, and others, it did not develop dormitory or housing policies. Groups such as the Inter-Residence Planning Committee and the Housing Advisory Board worked to coordinate and develop such policies. Sue Keagle (extreme left) had the job of keeping students involved, overseeing the need for changes, and developing student leaders.

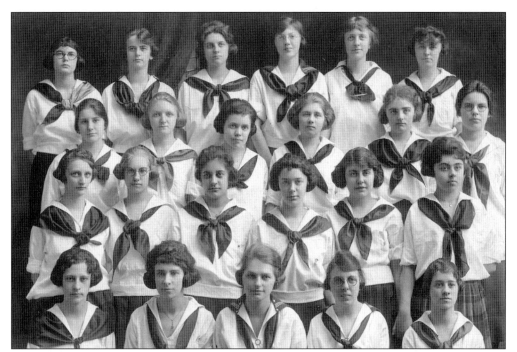

**AGONIANS AMONG WOMEN WHO PREVAILED, 1919–1920.** During the decade from 1910 to 1920, the men's societies declined dramatically in membership and their activities were sharply curtailed. The four women's societies, including Agonian, were doing very well. Initiation activities in the women's group came to the attention of authorities as some young women claimed to have been embarrassed. None of the activities seemed harmful or related to drinking, but members expressed a liking for dances, theater parties, and picnics—and not those incidents such as proposing to strangers, dressing in funny clothes in public, or singing downtown. In this photograph, the 23 sisters are dressed as much alike as possible, another example of sisterhood or togetherness.

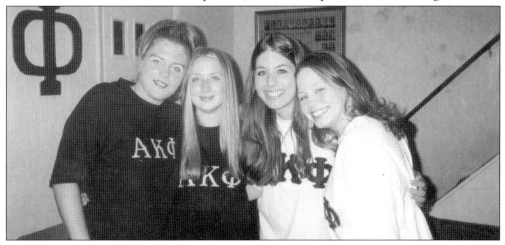

**AGONIANS AT THE TURN OF THE CENTURY, 1999–2000.** Now called Alpha Kappa Phi, the Agonians have had a reputation for maintaining college traditions and helping the needy. For example, they coordinated supporting activities for the candlelight ceremony in the 1960s. They have sponsored needy families and held jazz concerts, talent nights, Agonian Slave Sales, and Christmas parties.

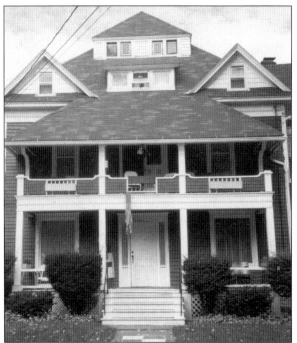

**ARETHUSA HOUSE, 27 CEDAR STREET, 1999–2000.** On October 20, 1894, the Epsilon chapter of Arethusa came into existence. In 1895, Arethusa was a major participant, along with Clionian and the Delphic male society, which presented the commencement play. Interest in Greek life has gone up and down over the years, with the most successful sororities being those purchasing houses, thus providing an incentive for sisters to live together in their junior and senior years. These large Victorian homes had many rooms and were generally in the direct vicinity of Old Main. By ownership or long-term lease, a sorority was able to have not only housing but also a social center and planning center for its activities. (Courtesy of Hunt Union.)

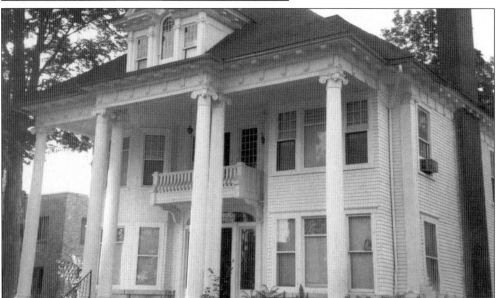

**THETA PHI EPSILON, 41 WALNUT STREET, 1955.** During the mid-1950s, Theta Phi held social functions at 41 Walnut Street for a short time. Built in 1909, this was the home of Burton Morris, son of Albert Morris, the first mayor of the city of Oneonta. Burton Morris was associated with his father in the feed-and-grain business. The house is in the best neoclassical style, with many of the traditional embellishments. Located in the historical district, it was probably not particularly suited for sorority-type activities. Greek life, in general, prospered throughout most of the 1960s, with fraternities doing a little better than sororities. Theta Phi Epsilon, as a struggling sorority, did not exist after the mid-1960s, and Alpha Delta Beta did not survive the end of the decade. (Photograph by David W. Brenner.)

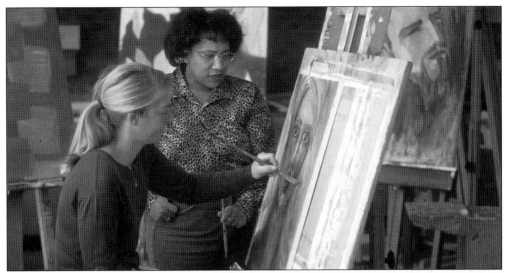

**YOLANDA R. SHARPE, ARTIST, TEACHER, AND SINGER, 2001.** As the faculty and student body became more diverse during the last third of the century, people like Yolanda Sharpe became crucial to promoting the understanding of racial issues. Her style has been one of gaining respect and promoting awareness by giving of herself (usually by explaining her art), interpreting comments and their contexts, or performing songs that help to teach others to appreciate African American culture and history. Her paintings have been exhibited in Studio Museums in Harlem, the Detroit Institute of Art, a solo exhibit in Japan, and in the Munson Williams Proctor Institute. She has been awarded the SUNY Chancellor's Award for Excellence in Teaching and Creative Work. (Courtesy of College at Oneonta Public Relations Office.)

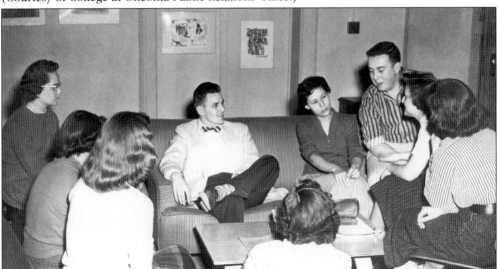

**STUDENTS FROM OTHER LANDS, 1957.** The International Relations Club was active since the 1930s. While the club sent members to conferences and promoted social causes, it was not until the late 1940s that efforts were made to help individual foreign students. In 1948, the club helped with a Dutch student's expenses. A year later, a Greek student attended for a semester. In 1950, a Lebanese student was helped by the faculty, students, the Bugbee Foundation, and some citizens of Oneonta. In this photograph, students from the International Relations Club and others are meeting with Anton Gotsche, a student from Austria.

**Oneonta Helps in the War Effort, 1917–1918.** The coming of World War I interrupted the serenity of student life. About one sixth of the student body was involved in war projects, including selling War Savings Stamps, working on war projects in factories, planting gardens, and donating proceeds of performances to the war effort. When Emory Pottle (Class of 1895 and a veteran of the American Ambulance Field Service) visited the campus, he requested the school to raise funds for an ambulance. The school raised more than $1,000 and purchased an ambulance, shown here.

**Helping the Farmers in the Oneonta Area, 1943.** Lt. Richard Brown, who had left Oneonta in 1942, earned a Distinguished Flying Cross. He was later killed in action. Maj. Emerson Dedrick (Class of 1937 and a Marine Corps member) was killed in action in the Pacific. Gerald V. Hutton also received a Distinguished Flying Cross, and Lt. Alton C. Miller was awarded the Air Medal. Winifred A. Robinson, of Ballston Spa, New York, served as an American Red Cross staff assistant in England. All of the work, however, was not overseas. Students were recruited for wrapping surgical dressings, planting victory gardens, replacing men at custodial jobs, and (as shown here) picking beans and other crops. These workers, frequently called farmerettes or victory girls, made a significant contribution to the local Oneonta war effort.

**MARKETING CLUB WINS AWARDS, 2001.** The Oneonta Marketing Club was recently recognized as the top chapter in the east of the American Marketing Association. The club's adviser, Stephen Walsh, was selected as the American Marketing Association's outstanding faculty adviser for 2000–2001. Club members gained hands-on experiences through involvement with local businesses and community organizations. The club participates extensively in community service activities, including fundraising walks, bowl-a-thons, and other activities to raise money to fight world hunger. The club exemplifies the themes of helping others and building character, which are both emphasized at Oneonta. (Courtesy of College at Oneonta Public Relations Office.)

**ACADEMIC TEAM MEMBERS: AN ORGANIZATION FULFILLING A NEED, 2001.** Recognizing that learning does not stop at the classroom door, the College at Oneonta now bridges gaps between the residence halls and the classrooms through an academic peer-mentoring program, staffed by successful students called Academic Team Members (ATMs). The ATMs—effective students with academic expertise and an appreciation of achievement—have become an important part of the residence hall environment, answering questions about academic policies, referring students to appropriate services on campus, organizing academic programs, and recognizing the academic achievements of students in their buildings. This photograph shows an ATM training class held in Milne Library in April 2001. (Courtesy of College at Oneonta Public Relations Office.)

RADIO COMES TO ONEONTA, 1962. In 1962, a small group of students, led by Gary Sparaco, formed a radio club and built a small station in Old Main. By 1964, they had more than 200 participants and broadcast from sunrise until midnight. Throughout its history, interest has remained high for WONY. The photograph above shows the membership of the Radio Club WONY-620KC in 1963. (Courtesy of the 1965 *Oneontan.*)

THE PRODUCING OF TELEVISION PROGRAMS, 1994–1995. Oneonta students operate a radio station, participate in video production of public events, and develop television broadcasts for the campus and public access channel. The college maintains two television production studios and a mobile television production unit, which is used for remote broadcasts from surrounding communities. The college aids in the production of the Muscular Dystrophy Telethon, local public access educational programs, game and talk shows, and special events, with students frequently serving as directors, hosts, and participants. This photograph shows a recent student, Elroy Huyghue, preparing for one of his shows. (Courtesy of College at Oneonta Public Relations Office; photograph by Bill Denison, 1995.)

**DELTA PHI KAPPA: THE SPORTS FRATERNITY, 1955.** Delta Phi Kappa was one of two fraternities that had roots in the normal-school era. However, it had become defunct, probably due to lack of men in the late 1930s and early 1940s. In 1947, the Men's Council reorganized the fraternity, and it became the Eta chapter in the spring of 1948. The fraternity's motto is "scholarship, loyalty, and brotherhood." The group has sponsored fun fairs, jazz concerts, and the Valentine Ball. During the 1950s, it was the "sports" fraternity, as nearly every member of the baseball and basketball teams belonged to the group. Their membership usually numbered about 45. (Courtesy of the 1955 *Oneontan*.)

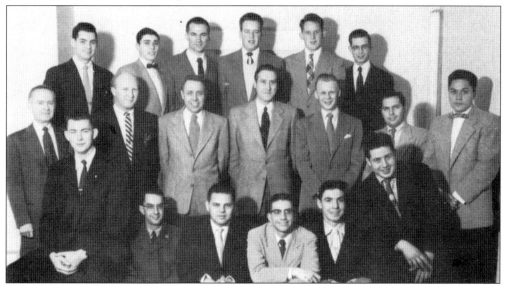

**SIGMA TAU ALPHA: THE QUIET ONES, 1955.** Reestablished in 1948, Sigma Tau Alpha gained a reputation as a serious group, which recognized and practiced positive social relationships, including the need to maintain good academic grades among its members. Sigma Tau Alpha sponsors the Hugh Hanna Memorial Scholarship, Heart Fund activities, and the White Rose Ball. Following up on its concern for serious academic pursuits, the fraternity presented a scholarship cup for several years to the dormitory with the highest cumulative grade point average for each academic year. (Courtesy of the 1955 *Oneontan*.)

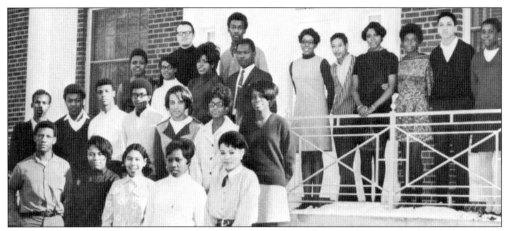

**ACTIVITIES OF THE AFRO-AMERICAN CULTURE SOCIETY AND THE STUDENTS OF COLOR COALITION, 1969 AND 1999.** In 1968, the Educational Opportunity Program was initiated, with its first class being a group of 50 students. While most were black or Hispanic, there were others who also qualified and were enrolled in the program. In 1969, the Afro-American Culture Society was formed and held its first event, a soul dance in February. Meetings and projects were held throughout the year, emphasizing the students' black culture and attempts were made to familiarize the rest of the community with it. Prominent in this effort was the Third World Association, which brought Julian Bond, Rev. Jesse Jackson, and other speakers to the campus. Conferences, black-oriented plays, dinners, exhibits, and other commemorative events took place on the campus, sponsored by the Educational Opportunity Program (EOP) and other black faculty members. Concern for increasing minority student enrollments was continuous. In 1987, there were 296 students in the EOP, and a considerable number of minority students not enrolled in the EOP but admitted under regular admissions policies. While diversity on the Oneonta campus was being accomplished, it did not come easily. During the late 1980s, several incidents with racial overtones occurred, including the "blacklist" incident. In that incident police, searching for a person who attacked an elderly visitor to the community, questioned many blacks. President Donovan and the Affirmative Action Committee renewed their efforts to enhance and maintain "a hospitable climate on campus for diversity and multiculturalism." These efforts are ongoing, with the latest student organization, Students of Color Coalition, continuing the work of providing insight and understanding of the need to promote diversity as a means to strengthen our society. (Courtesy of the 1969 and 2000 *Oneontan*.)

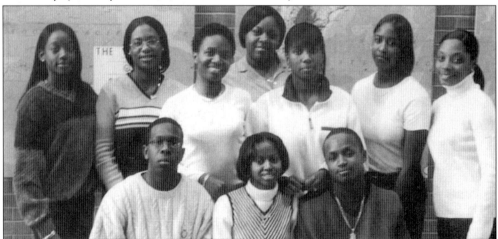

# *Four*

# COMPETITIONS
# AND PERFORMANCES

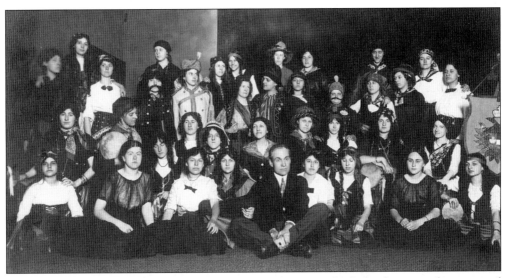

**BOHEMIAN GIRL AND THE AGE OF THE OPERETTA, 1910–1928.** The lack of men students caused major changes in the dramatic productions, starting *c.* 1910. Several societies that previously had reasonable numbers of males disbanded after the male enrollment decreased to nearly none. The rise of the operetta was stimulated by Elizabeth Gleason, a music instructor and occasional performer. Several times, faculty members filled male roles and, from time to time, female faculty and students played them, prompting some wags to wonder "how women can make love convincingly" and "whether another of man's vocations had been taken away." In *Bohemian Girl* (1913), Prof. Arthur Curtis was the director. Faculty member Carrie I. French acted in the program. Most roles were female, and it is safe to assume that the occasional male role was played by a female also. The operetta era saw the production of 19 shows, including the classics such as *Pinafore* (twice), *The Mikado, The Gondoliers, Priscilla* (twice), *The Little Princess,* and *A Midsummer Night's Dream.*

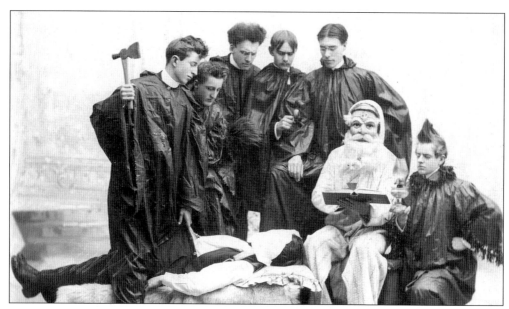

**THE PHILALETHEAN SOCIETY IS FORMED, 1891.** This society of men was organized primarily as a literary and debating group and soon became a full-fledged partner in planning commencement programs with the other five societies. In 1901, the society produced *As You Like It,* by William Shakespeare. While most of the students belonged to one of the societies—as a means of socializing—they still had to be initiated (and accepted) into the group. Some initiations were serious (and somewhat embarrassing or humiliating); others were spoofs and comedic from the beginning, such as the one pictured here.

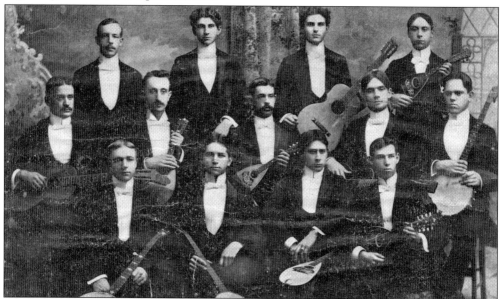

**SOCIETIES AND THEIR MUSICAL AFFILIATES, 1901.** Each of the societies had a glee club, banjo club, or some combination of musical groups. During this short period (several of the societies did not survive the first decade of the 20th century), the musical groups competed with other groups, traveled throughout upstate New York, and provided many performances during the school year. Pictured here is the Banjo Club of the Philalethean Society.

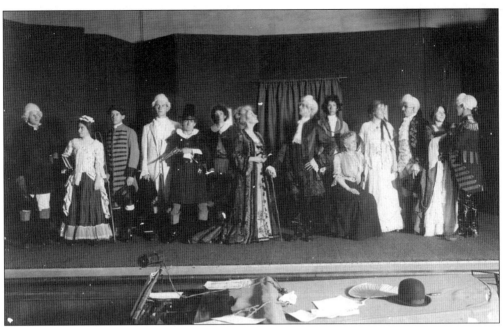

SOCIETIES AND THEIR PERFORMANCES, 1908 AND 1911. Although the societies had many pleasant social occasions, their main purpose was to expand their intellectual pursuits. Clubs were started with academic orientations, including learning about foreign languages and other lands and cultures, along with their social outings such as hayrides, dinners, and teas. One area left almost completely to the societies was the producing of dramatic productions. Unlike athletics, which had to struggle for attention and support, dramatic performances were praised and made an integral part of commencement exercises. The societies often combined to pool their talent in order to make their productions better. In some cases, faculty members performed also. In these pictures, we know that the Clionian, Arethusa, and Delphic societies combined to produce *The Rivals,* and it is safe to assume that the operetta *Robin Hood* (below) also had a cast of combined society members.

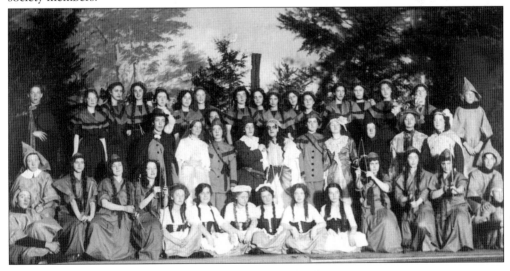

**DR. JOSEF A. ELFENBEIN, PROFESSOR AND THEATER ADVOCATE, 1948–1987.** Nothing deterred Dr. Josef A. Elfenbein from creating outstanding dramatic productions. While he drove students hard, everyone knew his goal was to direct the best shows possible. He was energetic and multitalented, including the ability to write, direct, and teach the student or faculty member how to act. Starting in 1948, he expanded the number and kind of dramatic presentations, sometimes aiming them toward children (as the Dragon Wagon plays) or linking them with pivotal dates, such as Alumni Weekend or holidays. He popularized arena theater. However, his greatest talent was the ability to stay focused on the expanding department, planning for theater, and recruiting faculty members who were able to carry out many of his goals. When Elfenbein received the Alumni Award for Outstanding Achievement in 1979, his colleague Brian Holleran wrote that all were touched by his kindness and generosity of spirit and concluded that the college was culturally and academically strengthened because Elfenbein lived and worked there. The author was gladdened when the Speech Communication and Theater section of the fine arts building was named for Elfenbein.

**DR. MURIEL KELLERHOUSE, FROM HIGH SCHOOL TEACHER TO COLLEGE PROFESSOR, 1960–1990.** After teaching a few years in an area high school, Muriel Kellerhouse joined the Department of English and Foreign Languages prior to its being reorganized into the Speech Communication and Theater Department in preparation for the college's transition into a comprehensive liberal arts college. One of her earliest plays as a director was *The Diary of Anne Frank,* offered in March 1962. Later, she became responsible for directing the very popular spring musical scheduled for Alumni Weekend, including *Once upon a Mattress* in May 1966, and the popular *The King and I* in 1967. Ed Pixley, Richard Siegfried, Ted Kottke, Ernest Battle, and Fred Miller also directed plays during this period. From time to time, talented students directed plays and a couple of them wrote original works, including Robert Preston, who had a successful career in theater. Throughout her career, she collaborated with Josef A. Elfenbein on several plays.

84

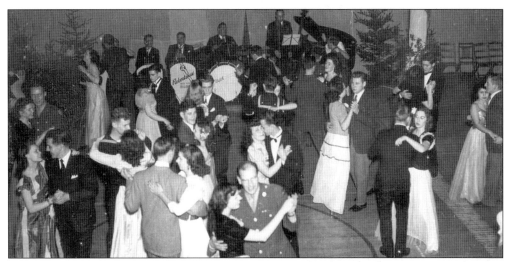

**COMBATING THE MALE SHORTAGE, 1944.** During the years of World War II, fewer than 10 men were in attendance annually. By the spring of 1944, there were more than 100 former students and graduates in the service, with about 25 percent serving overseas. The shortage of males caused campus social activities to be changed. Picnics, informal dinners, lodge outings, open houses, and war effort projects replaced dating and dancing opportunities. In December 1944, the junior prom, the first formal dance in three years, was held with 38 servicemen being invited from the Medical Detachment at Rhoades General Hospital in Utica. Since they had not met, a reception committee paired couples by height. A few months later, members of the sophomore class journeyed to Rhoades Hospital to entertain wounded soldiers. (Courtesy of Alumni Affairs Office.)

*DEAR RUTH,* **A MILESTONE IN DRAMA, 1955.** Mask and Hammer, revived as a dramatics club in 1946, expanded its programs under the tutelage of Dr. Josef A. Elfenbein, who became its adviser in 1948. An innovation appeared in March 1955, when the play *Dear Ruth* was presented in the arena theater format. For that first production, 250 chairs were placed around an open stage in Morris Hall. Arena theater productions became very popular and, in 1962, part of the gymnasium in Old Main was renovated into a permanent arena theater.

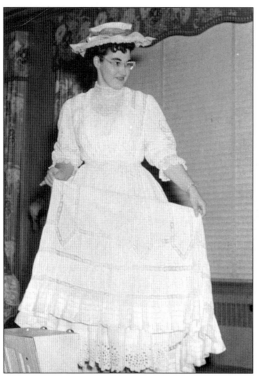

**SHARON COOK: PERFORMING IN A FASHION SHOW, 1956.** Just as societies, sororities, fraternities, and clubs put on special events, there were times when academic departments did also. In this photograph, Sharon Cook is performing in the Gay Nineties fashion show, sponsored by the home economics department on April 16, 1956. Such events highlighted both the students' ability and poise. It also displayed the materials or projects that were being assembled, presented, or studied.

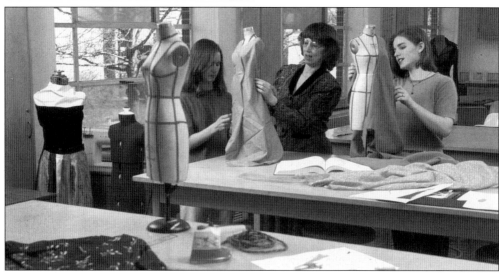

**DR. LORAINE L. TYLER FACES A CHALLENGE, 2001.** Dr. Loraine L. Tyler has a Ph.D. in housing and consumer studies from Virginia Polytechnic Institute and State University, 1982. Serving as department chair, she faces the task of overseeing the complete renovation of the Human Ecology Building, a facility that is more than 50 years old and is slated for a state-of-the-art upgrade. Tyler has an extensive background in housing, textiles, design, and energy education. She is a recipient of the SUNY Chancellor's Award for Excellence in Teaching. She serves the community by chairing the City of Oneonta Zoning Board of Appeals and the Housing Board of Appeals. She coordinates the college's popular 3-2 program with the Fashion Institute of Technology. (Courtesy of College at Oneonta Public Relations Office.)

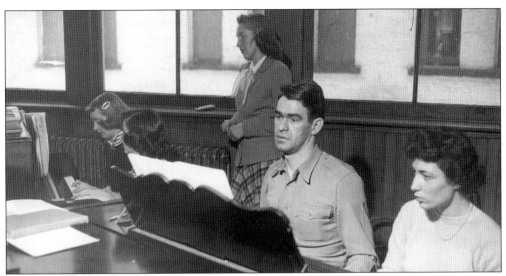

**RAYMOND CRANE, PERFORMING AND COMPETING, 1951.** In the days when the college was a teacher-training institution, primarily at the general elementary grade levels, it was a music requirement that each student be able to play some rudimentary tunes on the piano. For those with little or no music background, this requirement was a major concern. Men students, particularly the older or veteran types, seemed to struggle the most. In this photograph, Raymond Crane, a good student and outstanding athlete, is shown with a student tutor, struggling to master the piano-playing requirement. In later years, students were able to show competency by using tapes, records, and other audiovisual materials as they taught music appreciation at the elementary level.

**THE COLLEGIANS: PERFORMANCES OF QUALITY, 1966.** The Men's Double Quartet, the Glee Clubs, the Choraleers, and the Jongleurs were all outstanding singing groups. None were more successful in promoting an interest in choral singing than the Collegians. Because of the energy, longevity, and interest of its director, Esther Hubbard Whitaker, the Collegians compiled one of the longest records on campus for a singing group. Membership was by audition only, and tryouts were arduous and competitive. The group had two goals: the enjoyment of singing different choral arrangements and to stimulate public interest in choral singing. Their many successful concerts and the fact that they were well received in different settings indicated they had gone a long way toward accomplishing their objectives.

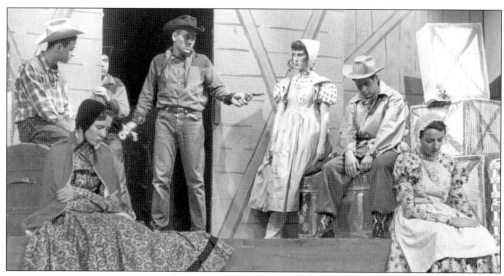

**DR. JOSEF A. ELFENBEIN WRITES A NEW PLAY, 1955.** Continuing his bent for the unexpected, Dr. Josef A. Elfenbein wrote *Tall-Tale and the Fast Freight* for the Children's Theatre Guild and his Dragon Wagon series. Showing his confidence in developing student talent, he had Bob Mullins, a senior, direct the play, which was a great hit among the younger audiences. The play was set in the West of the 1880s during the days of railroad pioneering. Four of the five men in the play were members of the Sigma Tau Alpha fraternity, adding to its reputation as a group of serious-minded students. (Courtesy of the Speech Communication and Theater Department.)

**ARMS AND THE MAN, THE SHAVIAN YEAR, 1956.** A reinvigorated Mask and Hammer Dramatics Club made up the cast of the play from its membership. Directed by Elfenbein, who again showed his versatility by combining graduate and undergraduate students in a play, choosing to do a lesser-known George Bernard Shaw work and agreeing to stage it again in September after an early August presentation. Elfenbein was interested because it was the 100th anniversary of Shaw's birth, and 1956 was designated the Shavian Year. George Bernard Shaw was an international institution, and some said he the "messenger boy of a new age" who "persisted in poking hornets' nests with a willow stick." The play's September performance was a huge success, and it left audiences wondering how a play could be presented so close to the opening days of the semester. Elfenbein knew how to do it: prepare, rehearse, and present it during the summer and have a rerun in September. (Courtesy of the 1956 *Arms and the Man* playbill.)

**DR. CHARLES C. BURNSWORTH, PERFORMANCES AND INCENTIVES, THE 1960S.** During the 1960s, the best-known group in music was the Women's Glee Club, directed by Dr. Charles C. Burnsworth. It brought international recognition to the college with its European tours. In 1968, the group joined with a men's group from Hamilton College and toured nine countries, where they were received enthusiastically. Between 1957 and 1972, the Women's Glee Club sang joint concerts with male groups from 16 leading colleges and universities in the Northeast. The Women's Glee Club also awarded Incentive Scholarship Awards. This undated photograph shows Burnsworth giving awards checks to Fay Belknap (left) and JoAnn Meade (right).

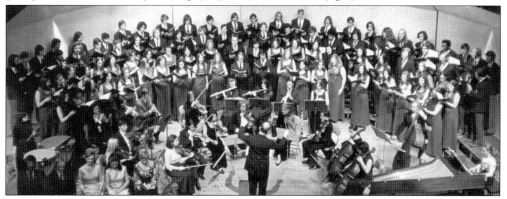

**THE COLLEGE MIXED CHORUS KEEPS A FRIEND, 1973–1974.** During the early 1970s, the Oneonta Mixed Chorus was invited to perform with the Syracuse Symphony. The first performance was conducted by the symphony conductor while subsequent performances were conducted by Dr. Robert Barstow, the College at Oneonta's mixed chorus director. The joint performances were a hit, and the chorus accompanied the Syracuse Symphony at several smaller community venues. The music department, during the 1970s and 1980s, sponsored the Concert Choir, various festivals of jazz, chamber music, music from other lands, and several joint ventures with community groups. In 1966, the music department faculty worked with the highly regarded Women's Glee Club, Concert Band, Peppy Dragons, the Collegians, Jongleurs, Choraleers, and the Men's Glee Club. The music department has had a faculty that has been generous in the use of its time to create, perform, and provide the best musical experiences for students and the community.

**"OH, WHAT A BEAUTIFUL MORNIN'"** *(OKLAHOMA!)*, **1963.** When the lights dimmed and John C. Worley, conductor, in his white tuxedo, stood in the spotlight and Elfenbein's name appeared as director, the audience knew it was in for a treat, especially when it came to musicals. Artistically and technically correct, the performances were just about everything one could expect from students. *Oklahoma!* was no exception. Additionally, the Alpha Psi Omega Awards for drama were presented to the best actor and actress, two supporting roles, the outstanding performance of a technical assignment, and the senior who had contributed the most to dramatics during his or her undergraduate career. Awards were presented following the *Oklahoma!* final curtain. The audience waited, with the tunes still sounding in their ears—and another successful Mask and Hammer evening was enjoyed by all. (Courtesy of the 1963 *Oklahoma!* playbill.)

*ONCE UPON A MATTRESS,* **1966.** This version of a longtime classic, directed by Dr. Muriel Kellerhouse, was well received. The Mask and Hammer Dramatics Club was building up a roster of outstanding performers. The show had a new combination of Muriel Kellerhouse as director and John C. Worley continuing as music conductor; the audience did not seem to mind, proving once again that Josef A. Elfenbein was building a program that would make a contribution to the cultural life of Oneonta. The Alpha Psi Omega Drama Awards had become a highly anticipated fixture. Nine outstanding senior awards had been given for the years 1955 and 1964. Eight outstanding actress awards and five actor awards had been given. There were only three supporting actress awards and five supporting actors. Nine technical performance awards were given. (Courtesy of the 1966 *Once upon a Mattress* playbill.)

*ROMEO AND JULIET:* **A CLASSIC REVISITED, 1985.** Dr. Theodore Kottke directed this all-student production in November 1985. The play was presented in William Shakespeare's five-act format, with two 10-minute intermissions. While the acting was very effective, the costumes and stage settings were superb. Set construction and design was one of Kottke's specialties. His work, particularly in children's theater and Dragon Wagon, reflected those interests. The production included musical numbers by a quartet from the period of the play, instruction for the fencing scenes, and consultation for the dance numbers. Faculty members Richard Siegfried, Theodore Kottke, Ed Pixley, and Fred Miller often directed little-known plays or those that appealed to students by providing a profound learning experience, such as political or social issues of the day. (Courtesy of the Speech Communication and Theater Department and the 1985 *Romeo and Juliet* playbill.)

*THE FOREIGNER* **ARRIVES, 1986.** *The Foreigner* was directed by Edward E. Pixley, another longtime member of the Speech Communication and Theater Department. The play was presented in the arena theater as part of the summer series. Familiar faces that appeared in the play were Dr. David L. Anderson (dean of liberal studies) and William Goertemoeller (a teacher in the Oneonta school district and an award-winning local actor). The summer series entailed the intimate arena theater, dinner, and the chance to see a mix of faculty, students, and local talent. The format made for a delightful and popular evening. (Courtesy of the Speech Communication and Theater Department and the 1896 *The Foreigner* playbill.)

**Dr. Harry E. Pence, Performance Extraordinaire, 1996.** Leading the commencement procession with his regal mace and upright bearing, Harry E. Pence lets the audience know that Oneonta means business: your son or daughter is a better individual—an educated person, equipped to face most of life's trials as a result of the time spent at Oneonta. Not only is Harry E. Pence a symbol, he is also an example of outstanding achievement. He has a Ph.D. in inorganic chemistry from Louisiana State University and has been awarded both the SUNY Chancellor's Award for Excellence in Teaching and the SUNY Distinguished Teaching Professorship. Interested in educational technology, he has produced several state-of-the-art publications and a CD-ROM entitled "Using Presentation Software for General Chemistry Lectures." He is well known for his innovative approaches to teaching chemistry and for his Web site "The Alchemist's Lair." (Courtesy of College at Oneonta Public Relations Office.)

**Dr. P. Jay Fleisher, Professor of Earth Sciences, 1998.** "North to Alaska!" is the cry from Dr. P. Jay Fleisher as he prepares to assemble another student group for research on the Bering Glacier in Alaska. Noted for his meticulous approach and patience, he firmly believes that undergraduate students can be taught to conduct substantive, good-quality research, especially if they have adequate preparation and a high level of interest. He is the recipient of the SUNY Chancellor's Award for Excellence in Teaching and has been awarded the rank of SUNY Distinguished Teaching Professorship. He has published numerous journal articles and conference presentations. He holds a Ph.D. in geology from Washington State University. (Courtesy of College at Oneonta Public Relations Office.)

**DR. JUNE C. EDWARDS: LOOKING OUT FOR OUR RIGHTS, 2000.** Dr. June C. Edwards's teaching specialties are censorship in schools, religion in public schools, and women leaders of social reform movements. Edwards has been honored with the SUNY Chancellor's Award for Excellence in Teaching. She is active as a guest columnist, speaker in various forums, and is regarded as a nationally known expert on the topics of censorship, history and philosophy of education, and religion in public schools. (Courtesy of College at Oneonta Public Relations Office.)

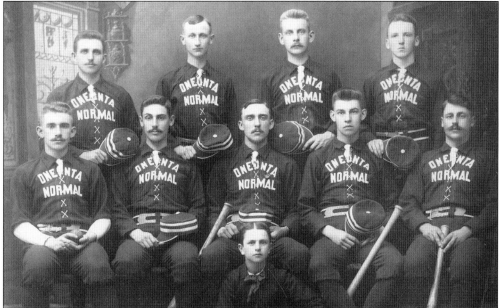

**BASEBALL STARTS AT ONEONTA, 1890.** In the spring of 1890, a group of students formed the Baseball Association, made up of students and other good players from the area. The association sold season tickets for $1 and generally played an eight- or nine-game schedule. During its first three years, the team had winning seasons, and the students supported it enthusiastically. Four years later, when it was not doing as well, student fans vocally criticized the players. In 1899, the Athletic Association (successor to the Baseball Association) recommended that only students be eligible for the team. Two years later, the team was made up of students only, but fan support or enthusiasm did not increase.

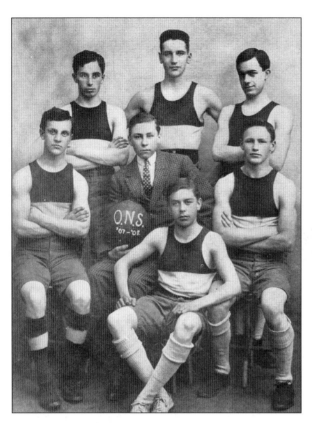

**MEN'S BASKETBALL, ANOTHER TENTATIVE START, 1907–1908.** Men's basketball started in 1904. The Old Main gymnasium had supporting posts that required padding to prevent injuries and changed how the game was played, requiring Oneonta to play its official games at the State Armory well into the l950s. In 1904, the men lost their first game 8-1 to a YMCA team. They lost twice to Walton High School 39-3 and 25-5. However, they defeated an Oneonta independent team 15-11 and Otego High School 50-4. Oneonta basketball teams labored in obscurity until the l930s, when they played such teams as Hartwick, St. Bonaventure, Arnold, and several normal schools and compiled a 17-3 record. Teams like the one pictured here were usually financed by the individual players and competed with independent teams or those organized the same way from other normal schools.

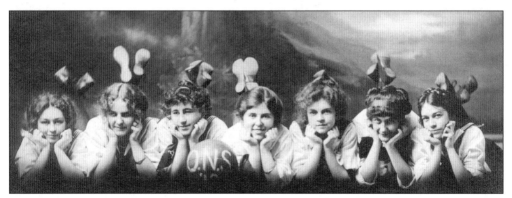

**WOMEN'S BASKETBALL, A TENTATIVE START, 1912.** During 1904, it was reported that a women's basketball team had been formed, but no record of its schedule or games won or lost seems to exist. In 1912, the women's basketball team had their picture taken and made into this postcard. Some bias existed toward women being actively involved in athletics; this may account for the women posing in a non-game setting.

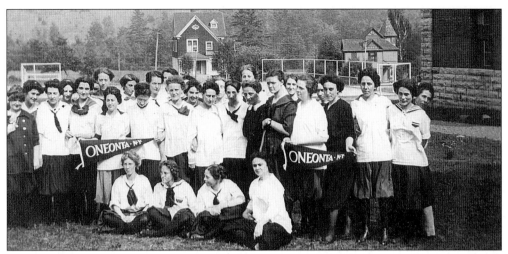

**WOMEN'S PHYSICAL EDUCATION, AN OUTDOOR CLASS, 1910.** During the first and second decades of the 20th century, the emphasis was on physical education rather than athletics or organized competitive sports. Elizabeth McLellan, the first physical education instructor, concentrated on drill and calisthenics as the best means of developing a "sound mind in a sound body." She conducted tests early in the terms to determine the needs of individual students. Repetitive drills (exercises that did not require apparatus or equipment) were used, and there were times when these were presented as demonstrations during chapel services. This photograph shows a group getting ready for an outdoor gym class in the area in front of the old power plant and near the site of the future Bugbee School.

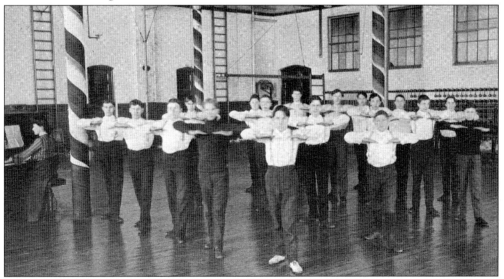

**MEN'S PHYSICAL EDUCATION, IN THE OLD MAIN GYM, 1904–1906.** Men did not escape the prevailing philosophy that calisthenics, drills, and exercises were good for you regardless of your involvement in other activities or sports. In this photograph we see men doing calisthenics, accompanied by a piano. The scene is the Old Main gym, and the supporting pillars can easily be seen. They were wrapped with cushioned bunting to protect players, particularly visitors, from injury. Oneontans generally developed moves and tactics that took advantage of the pillars. In later years, the gym served successively as an arena theater, data-processing center, and children's center.

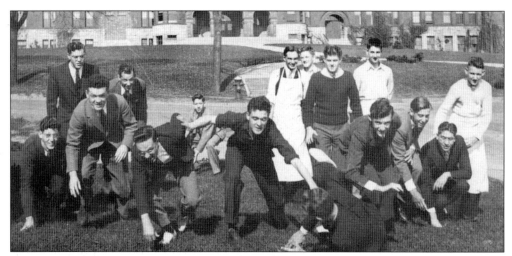

**FOOTBALL, THE NONSTARTER, 1904 AND THE 1930S.** In 1904, the school fielded a football team after some halfhearted attempts. Principal Bugbee and several faculty members helped pay for the uniforms. The team had a record of three victories, two losses, and one tie. On one occasion, the team played Friday, Saturday, Tuesday, and the following Saturday. With few or no substitutes, they vowed not to do that again, citing exhaustion as the reason. The possibility of reestablishing football was discussed by faculty members Jay Pawa and Hoyt Jackson in the 1970s. They went as far as looking into costs for equipment, uniforms, and such but detected little or no support from the Student Senate and faculty. Informal and intramural (tag) football is played on the campus. The 1930s photograph shows some students kidding around while "lining" up for an impromptu football game on the Bugbee School playground. (Courtesy of Alumni Affairs.)

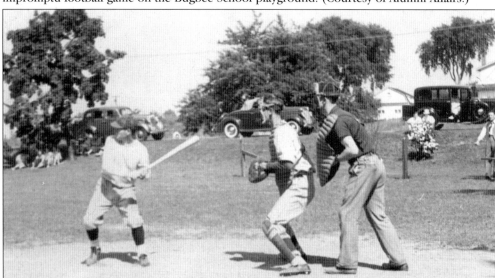

**BASEBALL, 1935–1936.** Baseball as a competitive sport languished in the 1930s. By 1939, after nearly a decade of student apathy and institutional lack of interest, baseball was no longer on the scene as an organized sport. Throughout the 1930s, however, there were attempts to organize town teams made up of some "star" players attending the normal school. Games were played on the Bugbee playground and other fields in the vicinity of Old Main between independent teams interested in competing with or against the normal-school students. In this photograph we see players in uniforms in what appears to be an organized game. (Courtesy of Alumni Affairs.)

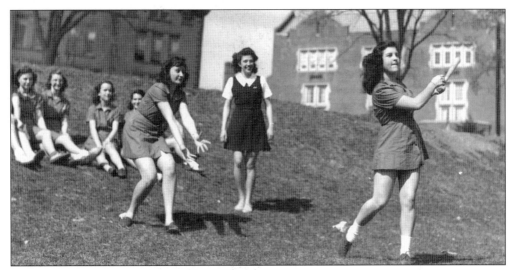

**WOMEN'S OUTDOOR PHYSICAL EDUCATION CLASS, 1946.** A half century later, gone are the long skirts, the long-sleeved blouses, the drills, and the calisthenics for women students. Instead, women students wore gym suits and participated in more active and competitive activities. The school still lacked first-class facilities for intercollegiate sports and was especially deficient regarding women's athletics. In this photograph we see women playing softball in the area known as the Bugbee Playground. The freedom of physical movement, to the point of serious exertion, and of women being able to participate in competitive, high-level athletics is just coming to the Oneonta athletic scene.

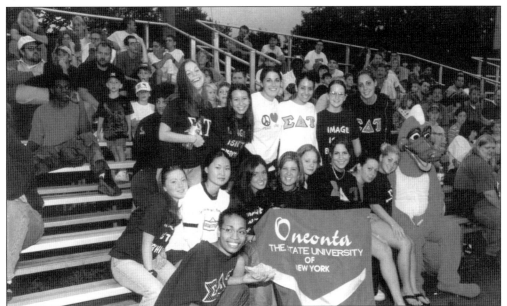

**SIGMA DELTA TAU, WATCHING THE COMPETITION, 1998.** Part of Greek life is joining the Dragon, Oneonta's mascot, at an Oneonta Tigers game downtown at Damaschke Field in Neahwa Park. The Tigers, a Detroit farm team, have sponsored nights, and one of the them is designated as College at Oneonta Night, with the Oneonta Alumni Association promoting the event. In this picture we see several women of Sigma Delta Tau, one of the eight recognized sororities, sitting on the front of the bleachers and watching the game. (Courtesy of Hunt Union slide files.)

**Dr. G. Hal Chase, Professor of Physical Education and Enthusiast for Life, 1948–1985.** Throughout one of the longest tenures in Oneonta's history, Dr. G. Hal Chase maintained a positive attitude toward the college, his students, and fellow faculty members. He was enthusiastic and interested in all phases of athletics, ranging from a two-on-two pickup game with anyone who was available to expanding course opportunities or arguing about increasing the departmental budget. With his spirit, vision, and tenacity he was able to move the department forward and expand Oneonta's participation in intercollegiate sports. Chase graduated from Cortland State and went to the University of Southern California for a master's degree. He then served as a tank commander in World War II. After the war, he earned a doctorate at the University of Buffalo. He was recalled for the Korean War. In the early years, he coached several sports and was particularly successful in basketball. As Oneonta became a multipurpose institution, Chase had the department prepared to offer more courses. He was one of the founders of the SUNYAC Conference. He had his share of controversies, including ongoing disputes with student government, which funded athletics with a share of the mandatory student fees. Coaches felt that the funds appropriated were not adequate in many instances. Even in the most difficult disagreements, no one ever thought Chase was less than sincere. He was generous in spirit and greatly animated when being persuasive. He would mix arguing and cajolery to such an extent that the listener would begin to think there was no other opinion. Coach Don Flewelling, a friend and longtime colleague, stated, "Whatever needed to be done, he would do. He hired me and he was the kind of man you did not want to disappoint. He cared about [building] programs and sought people who could help build something to be proud of." Chase helped build the foundation for many of Oneonta's athletic successes—both individual athletes and teams. (Courtesy of the sports information director's office.)

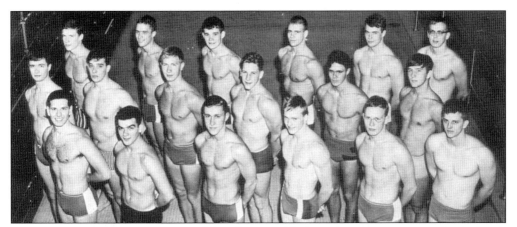

**THE MERMEN, A STUDY OF SUCCESS, 1966–1968.** In 1966, the Red Dragon swimmers finished with an excellent 13-1 season and took second place in the SUNYAC swim meet held in the Oneonta pool. Coach Don Ball's talented team ran its streak to 26 consecutive wins over a two-year period before dropping a 54-41 decision to Brockport State, which also won the SUNYAC meet by beating out Oneonta 74-67. By 1968, Oneonta had won the SUNYAC Championship three times in four years and had a five-year record of 58 wins and 4 losses. Outstanding in swimming for Oneonta were Malcolm "Ted" Bears (Class of 1968) and Haruske Naito (Class of 1978), both of whom were designated All-American and National Champions in their particular events, the 200-yard butterfly and the 200-yard breaststroke, respectively. The photograph shows the 1966 team, with Bears fourth from the left in the back row. (Courtesy of the sports information director's office and the 1966 *Oneontan*.)

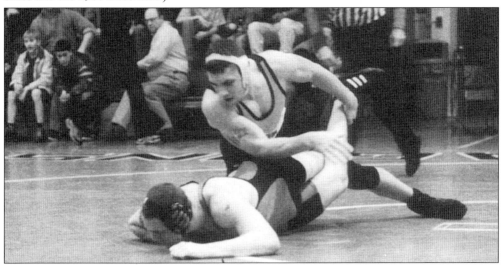

**ONEONTA SPORTS, SUCCESS IN EVERY SEASON, 1999.** The year 1999 was an exciting one for Oneonta athletics. At least one team in fall, winter, and spring saw postseason play, while three teams saw NCAA tournament play. Three Oneonta wrestlers earned spots in the NCAA Division III Tournament and made creditable showings. Spring lived up to expectations as both men's lacrosse and women's softball teams played in national tournaments. The women's softball won their first-ever SUNYAC Title. Heading into the national NCAA tournament with a 31-9 record, the team lost 5-4 to Keene State and 4-1 to Southern Maine in the double-elimination event. In all, seven women's teams and four men's teams went to postseason tournaments, securing three championships along the way. (Courtesy of the 1999 *Oneontan*.)

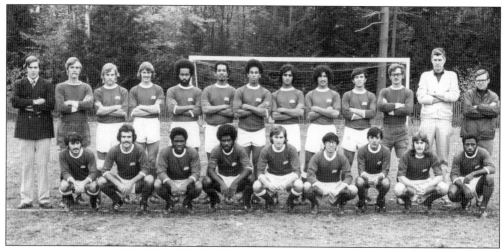

**ONEONTA ACHIEVES NATIONAL RECOGNITION IN SOCCER, 1972.** Seventeen years after soccer became a varsity sport at Oneonta, the college was in the NCAA College Division I Tourney. After achieving a 12-1 record and a fifth-place rating by New York State College Coaches Ratings, the Red Dragons defeated four teams to get into the finals against Southern Illinois, Edwardsville. Oneonta lost in the final game 1-0, bringing home the NCAA runner-up trophy. Several of the players earned All-American or All-SUNYAC honors, led by Farruk Quarishi, Bert Bidos, and Joe Howarth. (Courtesy of the sports information director's office.)

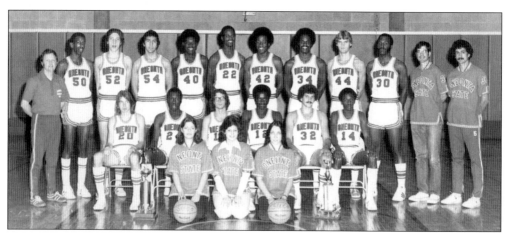

**BASKETBALL ENJOYS A RESURGENCE, 1976–1977.** During the World War II era, a great deal of sports activity was confined to intramural contests and informal play with community or independent teams. In 1946, the first major step in reestablishing a full intercollegiate program occurred when a basketball team played a limited schedule in the downtown junior high school gymnasium. G. Hal Chase brought the sports program along slowly but successfully (usually crafting winning seasons). By doing so, Chase was able to prepare the teams for stiffer competition, and the results were usually successful. Chase eventually relinquished coaching to devote his time to being department head. The basketball team had some lean years during the 1960s. In 1971–1972, Don Flewelling took over as head basketball coach. The team began to improve and received bids to postseason play. In 1976–1977, the team received its first-ever NCAA bid and acquitted itself very well. They defeated four teams in the national NCAA tournament and finished as national runner-up. (Courtesy of the sports information director's office.)

**FARRUKH QURAISHI, NATIONAL SOCCER PLAYER OF THE YEAR, 1974.** Quraishi, who grew up in England, achieved the highest honor of any men's soccer player in the history of Oneonta. As a senior, he was awarded the Herman Trophy as the National Soccer Player of the Year. The Herman Trophy is the soccer equivalent of the American football Heisman Trophy, which is given to the best football player. Quraishi was also selected College Player of the Year by *Soccer Monthly* magazine and was MVP of the Senior Bowl. In 1975, he was the first pick in the North American Soccer League (NASL) and was taken by Tampa Bay. At the end of his first season, he was selected as the Rookie of the Year and was a NASL All-Star. After his playing career was over, he became public relations manager for the Caspers Company, implementing national cooperative programs, sports sponsorships, charitable contributions, and government and media relations. He is currently the chief operating officer of Massachusetts Professional Soccer and owns three teams in the United Soccer League and a computer software company. (Courtesy of the sports information director's office.)

**GARTH STAM: SUNYAC COACH OF THE YEAR, 1971 AND 1972.** Garth Stam coached men's soccer for 28 years and led the program to unparalleled success. During his tenure, he compiled a record of 267-123-27, including a stretch of 62-6-5 from 1970 to 1975. He coached Oneonta to undefeated seasons in 1971 and 1973, leading the Red Dragons into the NCAA College Division final in 1972. Stam's teams won two ECAC titles, in 1977 and 1980, while winning or sharing four SUNYAC crowns in 1971, 1972, 1973, and 1985. He has coached all six of Oneonta's All-Americans and has had 18 of his players drafted into professional soccer. (Courtesy of the sports information director's office.)

**STEVE BLACKMON, ONEONTA'S ALL-AMERICAN, 1975–1976.** "He was the Pied Piper of Oneonta State," said former coach Don Flewelling. "When he was playing everyone wanted to see." Steve Blackmon was an outstanding player in the early 1970s, including being a 1,000-point scorer. He was a three-time All-SUNYAC selection and was the SUNYAC Player of the Year at the completion of the 1975–1976 season. That year, he was also selected by the National Association of Basketball Coaches as an All-American and was drafted by the Philadelphia 76ers. After playing professionally with the Long Island Ducks and in South America, Blackmon's rights were sold to the Boston Celtics, who wanted him to play in France. However, Steve Blackmon wanted to start on his career as a businessman. Blackmon and his family settled in Kingston, New York, where he started an electronics corporation. He spent time as a consultant, tutoring young minority people who wanted to start their own business. At the time of his sudden death in 1991, he was on a business trip for the Johnson Control Company of Milwaukee. (Courtesy of the sports information director's office.)

**F. DON FLEWELLING, A WINNING COACH, 1978–1979 AND 1983–1984.** Combative, competitive, excitable, and possessing an intense desire to win, coach Don Flewelling has shown other traits—those of longevity and versatility. During the late 1970s, the basketball team compiled records of 14-9, 15-8, and 7-14. The 1978–1979 team finished second in the NCAA Division III tournament. Captain Ken Ford made both the SUNYAC and ECAC All-Star teams. Flewelling was SUNYAC Coach of the Year. During the early 1980s, the team had two losing seasons, 1984–1985 and 1985–1986, but the team generally had winning seasons. Flewelling had a talent for developing players and winning regional tournaments. Steve Blackmon, Mike Pocyntyluk, Jackie Dalton, John Fleming, and Don McAvoy were players who received the benefit of Flewelling's coaching and counsel. Flewelling again earned SUNYAC Coach of the Year in 1983–1984. In later years, Flewelling coached women's softball to several successful seasons, including helping to develop Bonnie Busch Finn into one of the top softball players ever to play for Oneonta. Recently retired, Flewelling remains energetic and interested in the good that sports create for everyone. (Courtesy of the sports information director's office.)

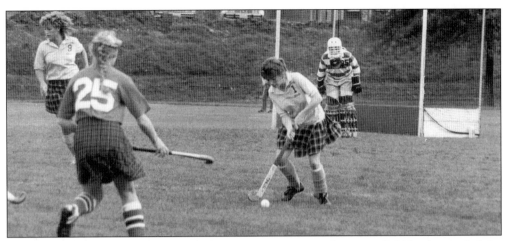

**FIELD HOCKEY, AN ONEONTA SPORT, 1977 AND 1990.** In women's sports, field hockey ended the 1970s with three winning seasons. The 1977–1978 and 1978–1979 teams had records of 6-2-3 and 12-2, respectively. They participated in state and regional tournaments. In 1979–1980, the team posted a 17-3 record, winning the Division III state championship, Division III regional championship, and finished third in the Division III nationals. In the 1990s, the team earned two berths to the NCAA tournament (1990 and 1992) and won the ECAC title in 1991, while qualifying for the New York State championship each of those years. The team was led by Lorena A. Coscio, a two-time National All-American, a three-time Regional All-American, three-time All-New York State selection, and a two-time Oneonta Female Athlete of the Year Award recipient. (Courtesy of the sports information director's office.)

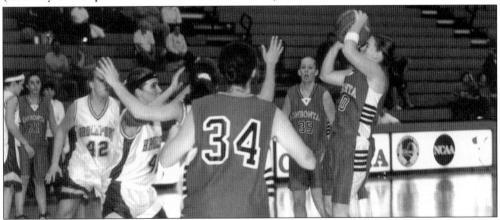

**WOMEN'S BASKETBALL, AN EVOLVING GAME, 1979 AND 1998.** In the early 20th century, women's athletic competitions were confined to sports days, play days, or invitational activity times. One exception was women's basketball, which did engage in formal intercollegiate contests up until *c.* 1928. Women's sports was sporadic throughout the 1940s and 1950s, with some intramural and organization-based teams playing others on an informal basis. During the 1960s, Oneonta women's sports gained momentum, led by aquatics, field hockey, and basketball. Women's basketball became a faster game, with more mobility, strategies, and speed. Twelve-game schedules were played, setting the stage for fan followings and more detailed record keeping. By the 1990s, the schedule had doubled. For instance, the 1998 team compiled a 25-3 record. The 1999 team, with a 9-16 record, played in SUNYAC tournament, losing to Geneseo. However, Paula Polce was an All-SUNYAC Honorable Mention and several others had excellent scoring records. (Courtesy of the sports information director's office.)

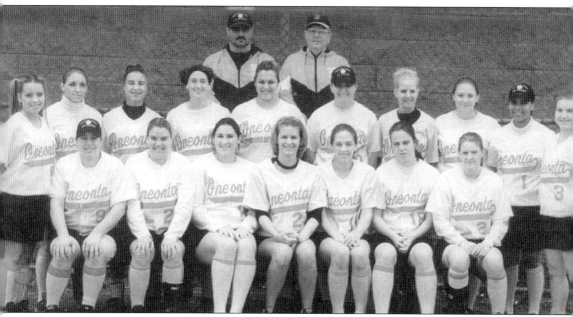

THE WOMEN'S SOFTBALL TEAM RELOADS, 2000. Coming off their first-ever NCAA appearance the previous spring, the softball team had their work cut out for them in trying to repeat as SUNYAC champions. The team had five starters return but lost a key pitcher or two. The team made the SUNYAC tournament but lost their first two games to Buffalo State and Brockport to end their season at 22-15. The last several successful seasons have sent the message that women's softball is here to stay. (Courtesy of the 2000 *Oneontan*.)

THE MEN'S LACROSSE TEAM WINS FIRST ECAC TITLE, 2000. The men's lacrosse team played some top teams in Division III, including National Champion Salisbury State, coming out with a 10-7 record and their first ECAC Upstate New York Championship. SUNYAC Player of the Year Brian Dooley led the squad. Because of the strength of their schedule, the Red Dragons were invited to participate in the ECAC tournament at Elmira. In the tournament, the Red Dragons defeated Oswego State and Elmira. Dooley scored eight goals, had nine assists over the two games, and was selected as the tournament MVP. It was not long ago when lacrosse was a club-level team, and it is a tribute to the coaches and players that Oneonta has become competitive in a relatively short time. (Courtesy of the 2000 *Oneontan*.)

## *Five*

# COMPLETION OF
# THE FIRST CENTURY

THE ONEONTA NORMAL SCHOOL FACULTY, 1892–1993 AND 2001. Principal James M. Milne assembled a strong group to help him launch the new school. However, according to today's methods of judging faculty competency, it would not have rated highly. Only three had master's degrees, while Milne had some advanced work. Five others had bachelor's degrees. Of the six without degrees, four were normal-school graduates and two had specialized training in music and elocution. There were more than 700 applicants for the 13 or 14 positions. One student commented that the teachers did not do the work for you, so when you got a diploma from Oneonta, you had earned it. Today, the faculty numbers 245 full-time and 160 part-time, supported by a staff group of 525. Oneonta faculty members are well prepared, with 176 (or 72 percent) having doctorates or other terminal degrees. The remainder have master's degrees and usually some work beyond. Students' reactions of today are the same; if you get a degree from Oneonta, you have earned it. (Courtesy of "Fast Facts 2001–2002," a publication of the Office of the President.)

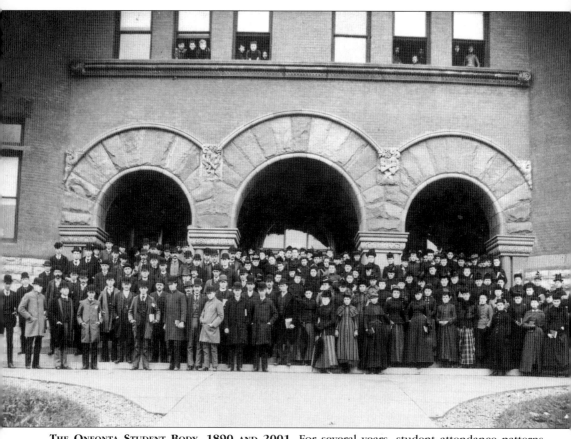

THE ONEONTA STUDENT BODY, 1890 AND 2001. For several years, student attendance patterns were irregular. The turnover in rural schools was rapid, and many students would withdraw in the middle of a term and take a teaching position. Standard entrance requirements imposed by the state help to stabilize the enrollment. Attendance averaged 105 students in the normal department and seven in the academic department, although there were 143 and 25 officially registered, respectively. During the second year, enrollment doubled and the average attendance was 222, while 294 enrolled and registered at the beginning of the term. From a first graduating class of 11, the numbers had increased to 57 by 1892. The average age of the beginning student ranged from 20 to 22. Today, the college has a full-time undergraduate enrollment of 5,126, a part-time enrollment of 216, and a graduate enrollment of 278, including 55 full-time students. The total number of degrees awarded in 2000–2001 was 1,042. The student body is now 20 times larger than a century ago, and the number graduating is nearly the same ratio. (Courtesy of "Fast Facts 2001–2002," a publication of the Office of the President.)

**OFFICERS OF THE SOCIETIES, 1894.** In the early years, the societies—Agonian, Dolphic, Clionian, Arethusa, Philalethean, and Alpha Delta—set the social agenda. In many instances, their members performed orations, wrote articles, acted in plays, debated contemporary issues, and, most of all, collaborated and provided many academically oriented activities during commencement week. This photograph shows secretaries, treasurers, and other officers of several societies. One person, Leonard Patton (sixth from the left), was the speaker at the 50th anniversary of the Class of 1895. He recalled his difficulties in securing a position. Finally, he took a job for $10 a week for a 36-week term. Later, he served as principal in several schools and was eventually appointed a supervisor of a Boston school district of 1,600 pupils. The societies encouraged student leadership and the taking of responsibility. Later, the societies evolved into fraternities and sororities, with their objectives being largely social.

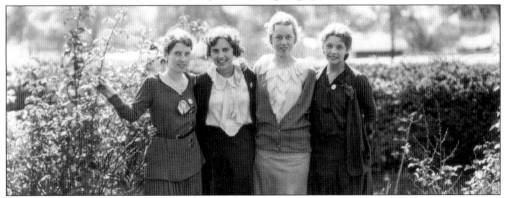

**CLASS OFFICERS GAIN INFLUENCE, 1933.** Not everyone was happy that societies (and, subsequently, fraternities and sororities) set the social agenda and encouraged activities that were detrimental to the individual student and the school. In particular, several faculty members were upset at certain initiation rites because they felt they were degrading and humiliating to young women. Other organizations were encouraged to assume a larger role in student social activities and personnel services. The Student League promoted healthcare for students, including mental health services. It also sponsored parties and dances. Special purpose clubs, such as the International Relations Club, began to attract student interest. A subtle change was the new emphasis, encouraged by Katharine Tobey and others to increase the role of class officers. Planning events and functions by class year was given increased attention along with promoting school-wide activities. This photograph shows freshman class officers of 1933. From left to right they are Marjorie Akin, treasurer; Eugenia Gordon, secretary; Esther Steere, president; and Dorothy Goodwin, vice president. The class motto was "When love and skill work together, expect a masterpiece." —John Ruskin.

**CHARLES W. HUNT AND ROYAL F. NETZER, VISIONARIES, 1933 AND 1951.** Dr. Carey W. Brush wrote that when Dr. Charles W. Hunt was appointed principal, the school was in need of new ideas, fresh scholarship, and a new concept of professional teacher training. In addition, the school had to weather the Great Depression, acquire degree-granting status, and essentially become a creditable college. Hunt had a broad background in education, many contacts in the profession, was unafraid of listening to faculty input, and, above all, had a vision of where the college should be heading. Some would say his greatest contribution was that he sensed that physical growth would be a problem and he was determined to secure additional land for the college to build on in the future. Land acquisition alone did not define Hunt's insight or worthiness; it was his ability to keep an institution going in the face of the Great Depression, World War II, declining enrollments, and an uncertain future. His kindliness toward faculty, his gentle prodding of the faculty to continue advanced study, his efforts to keep up faculty morale, and his willingness to serve on boards, community organizations, and take on positions of responsibility truly made up his vision of what the institution should be about. After a long tenure, Hunt retired in 1951, and a new president was appointed. Dr. Royal F. Netzer had an excellent background and education to take on this role. However, his main strengths were his aptitude for the political arena, a broad knowledge and interest in building problems, a more systematic approach to administering a growing institution, and a great deal of energy to see things through. These tasks alone would have evidenced the fine job Netzer did. However, his vision was more—he was direct, open, and approachable. His interest in seeing the campus expand in an orderly way was unmatched except by his energy as he checked nearly every project numerous times. His battles with contractors, developers, and sometimes state authorities were legendary. At the same time, academic pressures were building for more degree programs, more diversity in both faculty and student body, and higher standards. Netzer handled these tasks in an excellent manner, choosing effective administrators and teachers—and positioning the institution well for the future. (Drawing by Alberta Hutchinson.)

**DR. CAREY W. BRUSH, PREPARING FOR A MULTIPURPOSE INSTITUTION, 1963.** As the college prepared to have a comprehensive array of liberal arts programs, Carey W. Brush was appointed as the first director of liberal studies. In the 1960s, academic divisions, made up of what would normally be several departments, were beginning to feel the pressure to separate into discrete, smaller departments or disciplines. Brush was able to forecast areas of growth, arrange splits of divisions, and make sure that previous division directors, mostly senior faculty, knew that plans they had developed would no`t be ignored. This was especially true when they had put a great deal of time and effort into planning for the new buildings "up the hill." Brush and Dr. Katherine Hobbie, director of education, worked out many issues of potential conflict between the previously dominant education program and the newly developing liberal arts programs. Today, the college offers more than 65 majors, several preprofessional programs, and opportunities for international study and internships—all designed to be integral parts of the undergraduate degree. The fact that these programs are well articulated and largely non-duplicative is a tribute to the initial work of Dr. Brush, who subsequently served as vice president for academic affairs for many years and applied the values of competency, fairness, and respect for varying opinions on an institution-wide basis.

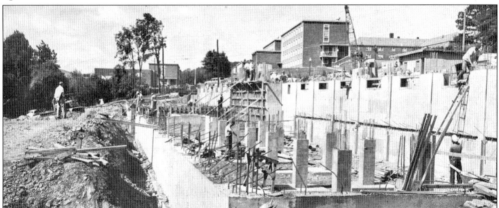

**A CAMPUS SYMBOL OF THE 1960S: CONTINUOUS CONSTRUCTION, 1963.** From c. 1958, the planned-for move up the hill (the construction of dormitories, classroom buildings, an administration building, and a student union) began to gain momentum. Eventually, 14 dormitories were completed and were able to house nearly 3,200 students, making Oneonta a residential college. It seemed that a new dormitory or some other building came on line every year throughout the 1960s and into the early 1970s. During that period, the college had two library buildings built, outgrowing the original James M. Milne Library in less than 14 years. Today, renovations have been made in nearly every dormitory, and the classroom buildings (including the fine arts building) have been renovated and outfitted with the latest technology to face the next century. (Courtesy of the 1963 *Oneontan.*)

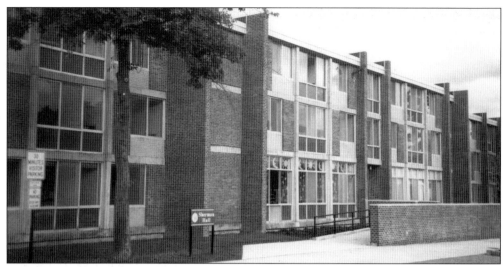

**ONEONTA BUILDS AND NAMES THE FIFTH DORMITORY, 1966.** After struggling for nearly 50 years with no college-owned student housing, dormitories were built rapidly in the late 1950s and throughout the 1960s. The fifth dormitory—and the second one in 1966—recalls the contributions of Frank G. Sherman, a member of the board of visitors from 1932 to 1936. Sherman attended Oneonta Normal School, taught school at age 16, was a businessman, and served as postmaster and (later) as state assemblyman. (Courtesy of "The Past as Present: The Story of Campus Dedications," by Martha Chambers; photograph by David W. Brenner, 2001.)

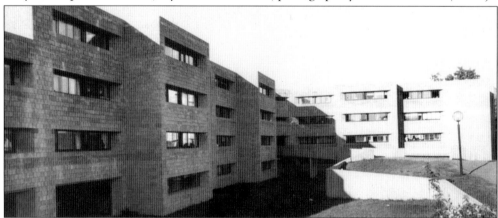

**HULBERT HALL DUBBED "PHIPPIE HALL," 1972.** Most of the dormitories looked like Sherman Hall, made up of two wings and common area. They were built on the perimeter of the campus, with several on the same contour and connected by paths leading to other dining halls, parking lots, or buildings. Hulbert Hall was an exception. It was built on a knoll away from the others. It was larger, housing 452 students, and had its own dining facility. It was not brick-faced like the others. Because it was not named officially before it was occupied, students called it "Phippie" after the first names of the initial directors. Phippie's appearance, made up of cold, gray concrete blocks, led to it being called "Attica East" and "contemporary penitentiary" in design. Heating and various construction problems plagued it from the beginning. Things were looking better when the building's surface was treated and it was painted to resemble the brick on other dormitories. Hulbert Hall was named for Burton J. Hulbert, a popular Oneonta banker and civic leader, who had always shown an interest in young people. (Courtesy of "The Past as Present: The Story of Campus Dedications," by Martha Chambers.)

**DORMITORIES GENERATE SCHOOL SPIRIT, 1989.** When societies, fraternities, and sororities diminished in importance to students, the rise of allegiance to your dorm filled a great deal of the gap. In fall, homecoming weekends, special parades, and other alumni-sponsored events are well attended on a dorm basis. This photograph shows Phippie Hall's float contribution to the homecoming parade. It paid tribute to the Old Main pillars and featured a scale model of the campus. (Courtesy of Hunt Union.)

**MATTESON HALL SAYS HAPPY BIRTHDAY, 1968 AND 1989.** The fourth residence hall was Matteson, named for Florence M. Matteson (Class of 1892), who spent 40 years teaching at Oneonta. She retired in 1933 after serving as head of the history department and dean of women for nearly all of her professional life. (Courtesy of Hunt Union and "The Past as Present: The Story of Campus Dedications," by Martha Chambers.)

111

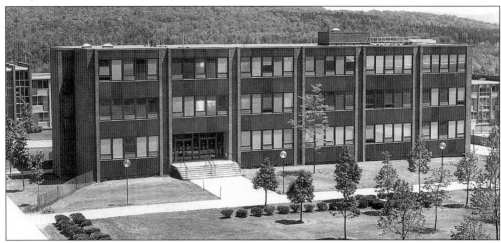

"ALL OF MY PROFESSORS HAVE BECOME BUILDINGS," 1964–1968. Catherine Muirhead Gallagher (Classes of 1940 and 1957G), a longtime Bugbee School faculty member and a Distinguished Alumnus, observed the buildings of the upper campus in the 1960s and penned a poem that exclaimed that all of her professors had become buildings. For Schumacher Hall, she wrote, "Schuy, Schuy, English Lit. / And a yardstick smoothed by years / of sliding through artistic hands, / as you taught your little dears. / Way back in those days of yore / All those 'children' did adore, / their white-haired prof, his friendly way; His notebook, 'one exponent A,' 'Crossing the Bar,' and 'one clear call' / —we hope you approve of Schumacher Hall." Schumacher Hall, the first upper campus building to be solely designed for classroom instruction, was named in 1966 for Prof. Charles R. Schumacher, a teacher of literature and methods from 1895 to 1939. (Courtesy of "The Past as Present: The Story of the Campus Dedications," by Martha Chambers.)

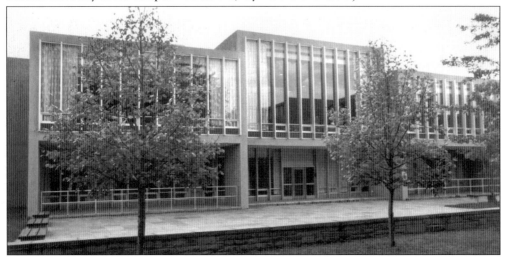

DINING HALLS ARE BUILT, 1966 AND 1968. With nearly 3,000 students being housed on campus, dining halls were a necessity. In 1966, the Mills Dining Hall opened. It was named in honor of Albert P. Mills, who taught English, economics, and public speaking from 1920 to 1942. He was known to be a demanding teacher but also as a hospitable and kind host to students in his home. Wilsbach Hall (pictured) opened in 1968. It was named for John L. Wilsbach, music department chairman and professor of music from 1933 to 1962. Wilsbach was a taskmaster of the first rank, a gifted organist, and a superb organizer of his pilgrimages, weekend trips to New York City. (Courtesy of "The Past as Present: The Story of the Campus Dedications," by Martha Chambers.)

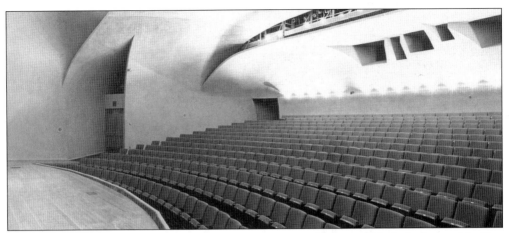

**THE LAURENCE B. GOODRICH THEATER: KINDNESS REMEMBERED, 1968 AND 1989.** At the heart of the Fine Arts Center is the Goodrich Theater. Dr. Laurence B. Goodrich was appointed head of the Department of English, Speech and Theater in 1947. Known as a demanding yet kind faculty member, he frequently hosted small groups of students at his home. As a colleague, he was much beloved for his habit of showing respect for everyone's opinion. Catherine Muirhead Gallagher wrote in 1989, "With Shakespeare, Browning, and drama writing / the things you always made exciting. / If only learners of today / could follow as you showed the way. Of course you are no longer here / for those of us who hold you dear. / Instead, your memory is enriched / by that beautiful theater called 'Goodrich.' / And so, Sir Laurence, take your bow, / Beloved then, beloved now." Donald Peterson wrote in 1968, "Remembering you. The world, now that you've left, it is no less yours. We live and breathe your lesson." (Courtesy of "All of My Professors are Buildings," by Catherine Muirhead Gallagher, and the 1968 *Oneontan*; photograph by Bill Rothschild Monsey and Francis X. Gina and Partners.)

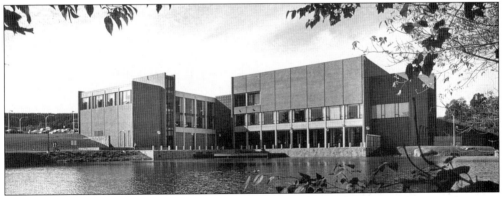

**HUNT UNION: TRIBUTE TO THE THIRD PRESIDENT, 1972.** While a great deal of care went into the design of Hunt Union, there was concern about its location—away from the center of the campus. After 30 years of experience, it turns out that the planners were correct. Functions of Hunt—a snack bar, an auditorium, stores, student government, a cafe, and planned social events—make it a pleasant destination. Dedicated the next year as part of the 25th anniversary of SUNY, the new building was a tribute to Dr. Charles W. Hunt, whose determined efforts to enlarge the campus helped ensure the college's survival. The facility itself—with its staff, design versatility, and ability to accommodate speeches, dinners, large social gatherings, commencement rehearsals, and smaller conferences—has helped the college's efforts to enhance its social environment. (Courtesy of "The Past as Present: The Story of Campus Dedications," by Martha Chambers; photograph by Bill Rothschild and Francis X. Gina and Partners.)

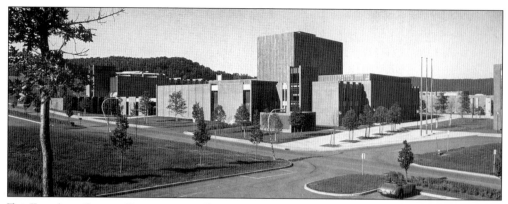

**THE FINE ARTS CENTER: ELFENBEIN AND GOODRICH MEMORIALIZED, 1968 AND 1987.** When the Fine Arts Center opened in 1968, it contained a state-of-the-art proscenium theater, an art gallery, numerous art classrooms and studios, a music wing, practice areas, faculty offices, and lounges. The building was built around a courtyard that has been used to display outdoor sculpture. Today, the center still houses the Departments of Art, Music, and Communication Arts. Within the building is the Elfenbein Complex, which houses the Laurence B. Goodrich Theater (named in 1968), the Junius Hamblin Arena Theater, the scene shop, costume shop, and makeup and dressing rooms. This complex was named in honor of Dr. Josef A. Elfenbein in 1987. Two recent facilities are the computer lab (for computer art) and the music listening and recording laboratory. These are in the art and music departments, respectively. (Photograph by Bill Rothschild and Francis X. Gina and Partners.)

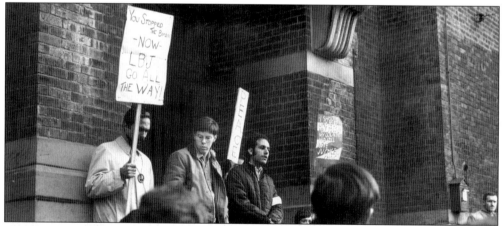

**STUDENT UNREST AND THE VIETNAM WAR, 1968–1973.** An early student protest rally occurred on November 4, 1968, with dissident students, sponsored by Students for a Democratic Society, protesting "no choice" in the upcoming presidential election and the increasing U.S. involvement in the war in Vietnam. The photograph shows speakers on the steps of the state armory after a march downtown. On April 29, 1970, there was a 22-hour sit-in, centered in the administration building. Students wanted a greater say in academic decision making, including power in the faculty hiring and firing process, greater involvement in the budgeting of funds, and the development of standards of conduct for faculty and students. The week of May 8, 1972, saw three sit-ins at the armed forces recruiting station downtown. Violence occurred when a local citizen drove his car through the crowd and a faculty member cut his leg. The following Monday morning, the protesters reappeared, with the rally turning violent in the afternoon. The police arrested 14 people, with one requiring several stitches. Early 1973 saw several more peaceful rallies, centered on the antiwar theme. (Courtesy of Ron Mitchell.)

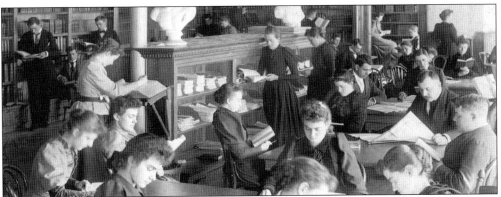

**THE NORMAL-SCHOOL LIBRARY: A STORY OF REVIVAL, 1890.** Critical to the academic and professional work of any institution is the library. Early circulars mentioned a practical references and reading room, which contained standard works of "pedagogical and general literature." The collection also included some monthly and quarterly periodicals, as well as a representative group of daily and weekly newspapers. By the summer of 1890, some 700 books were added, not including donations of classical works. Willard E. Yager of Oneonta presented the school with a collection of Indian artifacts along with 200 books. The fire destroyed nearly everything in 1894. In the rebuilding effort, more systematic approaches were used. C.W. Bardeen donated about 100 volumes on pedagogy and 75 volumes of his periodical. A special appropriation of $3,000 was spent on reference books. Early records indicate about $1,000 a year was spent on materials (including books), and the library increased its holdings at about 1,000 volumes a year. The legislature resisted a $600 request to pay a trained librarian. The school assigned a staff member part-time to assist students. The library was reborn.

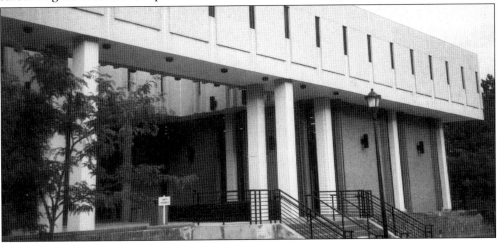

**JAMES M. MILNE LIBRARY, 1960, 1974, AND 2000.** The original James M. Milne Library opened in 1960 and was dedicated the following year by Gov. Nelson A. Rockefeller. The library commemorated the energetic leadership of the first principal of the Oneonta Normal School. However, its capacity to serve as a library for a growing institution was lacking, and it was outgrown in a little more than a dozen years. A glance at the *Annual Report 2000–2001,* prepared by Janet L. Potterb, reveals how the demands on library services are being met, and it gives some insights into the world of academic information technology services. In 2000–2001, the library has a collection of 549,243 bound volumes, approximately 28,500 government documents, and more than 1,700 subscriptions to newspapers and periodicals. For the same period, expenditures (state funds only) equal $1,911,362, with $1,199,031 being used for staff salaries. Numerous grants received throughout the year are used for specific projects or improvements. (Courtesy of *Annual Report 2000–2001,* by Janet L. Potter.)

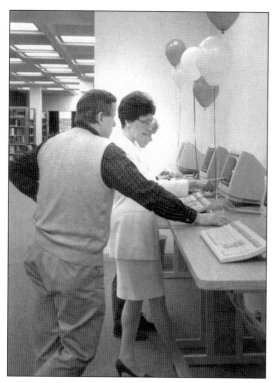

MULTILIS AND ACADEMIC INFORMATION TECHNOLOGY SERVICES, 1995 AND 2000. In 1995, the implementation of the MultiLis program, along with other changes, signaled the end of the card catalog as most of us knew it. In this photograph, Janet Potter, associate provost for Library and Information Services, is showing Prof. James Mullen of the art department how the system works. The area of information technology services is a burgeoning one. Potter reported 14 highlights in this area that were accomplished in 2000, including these five: Creating a Res Tech program to support student computing, improving training for all student employees, creating five new multimedia classrooms, implementing a new help desk software system, and completing the first year for Course Info from Blackboard. (Courtesy of the James M. Milne Library Archives and *Annual Report 2000–2001,* by Janet Potter.)

THE EDUCATIONAL OPPORTUNITY PROGRAM, 1968 AND 2001. During the late 1960s, there was university-wide concern about the low enrollment of minority students, particularly African American and those of Hispanic heritage. Special funding for support services was set up and the Educational Opportunity Program (EOP) was initiated in 1968, with a goal of 50 students who had the ability to profit from a college education to be recruited. Dr. Jay Pawa volunteered to help recruit, particularly in the New York City area. In the fall of 1968, EOP began, with 39 of the students being black. The program has been successful over the last 30 years, with enrollments averaging more than 200 each year. A substantial number of students has graduated and gone on to graduate and other professional schools. One of the main reasons for the success of the program at Oneonta has been its staff, including Stanley Morris, director for 27 years; Ed "Bo" Whaley, counselor for nearly 25 years; Cheryl Peeters, longtime secretary; and others, such as Jackie Hesse and Na'im Abdaraffi. This photograph shows the current EOP staff. They are, from left to right, as follows: (front row) Carole Rooney, Lynda Bassetee, and Nick Mitchell; (back row) Ed "Bo" Whaley, Henry Robinson, Linda Randall, and Cheryl Peeters. (Courtesy of the Educational Opportunity Program.)

116

**DR. EMERY WILL PRESENTS AN AWARD, 1960 AND 1980.** The Greek Sing Award, presented by Dr. Emery Will, was earned by Janet Pike Wemple, representing the winning sorority of the Class of 1960. At this time, Will was chair of the Science Division, which later split into five departments. Will masterfully guided this process and was instrumental in seeing that competent and respected faculty members became chairs. Dr. William B. Fink did the same for the Social Science Division, which split into six departments. Later in his career, Will was appointed director of Academic Advisement, with his system and its attention to detail earning national recognition. Each year, he published an updated advisement handbook and trained dorm directors, resident advisers, and faculty to be academic advisers. In what are normally regarded as student "troubled" areas (advisement and registration), surveys showed that about two thirds of undergraduates were pleased with how they were advised.

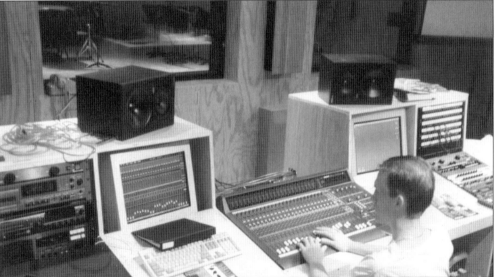

**THE MUSIC INDUSTRY MAJOR: AN INNOVATIVE COURSE OF STUDY, 1981–2001.** The Music Industry major has been in existence in Oneonta for nearly 20 years and now has several hundred students enrolled. The major includes both music and business economics courses. In Dr. Janet Nepkie's course on legal issues, such matters as copyright laws, talent rights, artistic license, and infringement cases are discussed. By posting cases to the Web prior to class, Nepkie provides opportunities for students to debate rulings prior to the class meeting. This picture shows Oneonta's innovative recording studio, using Michael Green's turntable room acoustics. This new technology allows one to align the harmonic structure produced by any performing group with the room's acoustical characteristics, thereby avoiding the undesirable effects of corner loading, slap echo, standing waves, and other sonic problems. Improved sound staging, increased levels of dynamics, and low-frequency extension are also achieved. Coupled with its shell design, the new studio presents the consummate recording environment for any size group or style of music. (Courtesy of the music department.)

DISTINGUISHED ALUMNI
TEACHER/VOLUNTEER

PHYSICIAN

DEAN

HOME
ECONOMICS
INSPECTOR

ATTORNEY

VETERINARIAN

MAYOR

STOCKBROKER

COLLEGE
COUNCIL
MEMBER

BANKER

COLLEGE
PRESIDENT

DEAN
OF
STUDENTS

GUIDANCE
COUNSELOR

OUTSTANDING
TEACHER

CHEM

DMISSIONS

CORPORATION
VICE PRESIDENT

ORMAN

YOUTH DIRECTOR

SPORTSWRITER

JUGGLER

SOCCER COACH

DEPUTY
SUPERINTENDENT

CONSULTANT

**SOME OF ONEONTA'S DISTINGUISHED ALUMNI, 1989.** Oneonta's alumni number approximately 44,000. During the first 75 years, the college's major mission was to educate and train teachers for the schools of New York State, primarily at the elementary level. Many alumni of this era reached responsible positions in educational endeavors, including being recognized as excellent teachers, principals, district superintendents, and college presidents. When liberal arts programs were instituted, graduates began to enter diverse fields. Oneonta alumni are now found in the ranks of attorneys, physicians, veterinarians, dentists, corporation presidents, bankers, stockbrokers, legislators, mayors, college professors, and directors of national charitable organizations. Alumni support their college financially and by volunteering in admissions recruitment, career development, College Council, and on the Oneonta Alumni Association Board of Directors. This illustration represents many of these alumni and their occupations. (Drawing by Alberta Hutchinson.)

**THE BUGBEE SCHOOL NINTH-GRADERS SAY THANKS, 1975.** The Percy I. Bugbee Campus School was used from 1933 to 1975 as a laboratory school, providing observation, participation, and practice teaching opportunities for majors in elementary and early secondary education. Maintaining a campus school came under attack for several reasons. It was expensive to maintain, and many thought that public schools could provide the same experiences. Some community members felt that it was too much like a "private" school for faculty kids. Also, the physical plant was aging and would need costly renovations to bring it up to standards. In this photograph, three ninth-graders are presenting a plaque to Dr. Kenneth Kellerhouse, principal, as a sign of thanks to the faculty and staff. (Courtesy of Dr. Kenneth Kellerhouse.)

**BUGBEE FINDS A NEW LIFE, 2000.** When Bugbee School closed its doors as a campus school, it provided space for other organizations. Several organizations were peripheral to the college's main mission but important in terms of providing needed services and obtaining state and federal grants. The Migrant Tutorial Program was housed in Bugbee, allowing it to provide space for a day-care center, in-school tutorial assistance, parent education, adult basic education, and rural disadvantaged youth employment. Bugbee, after its closing, initially housed RIM (Resources, Ideas, and Materials), which sponsored workshops, conferences, exhibits, demonstrations, and library materials to aid students, faculty, and area schools. Soon, the Migrant Education Program and an expansion of the day-care center to include children in addition to those of migrants occupied nearly the entire facility. (Photograph by David W. Brenner.)

**CLIFTON R. WHARTON, CHANCELLOR OF STATE UNIVERSITY OF NEW YORK, VISITS ONEONTA, 1980–1981.** In January 1978, Clifton R. Wharton was appointed chancellor. Wharton observed a SUNY central administration that needed stability and reorganization. He also sought more freedom so that SUNY could plan its own destiny. He proposed a "multiphase rolling plan" that would enable SUNY to anticipate available state resources and their impact on academic programs. Individual campuses would plan accordingly upon receipt of their allocations in the system-wide plans. Wharton wrote that he would put forth a sustained effort to see that planning, decisions, and recommendations were carried out. President Craven endorsed the plan, stating it would allow the local campus to plan better. Overregulation was a problem. In 1984, SUNY received much more flexibility in purchasing, fiscal, and personnel matters. On the local level, Craven pushed his private fundraising initiatives, hiring former Geneseo president Robert MacVittie (Class of 1944) to head the Alumni Affairs office, and readying plans for a private college foundation, devoted to raising funds from the private sector. He could see the direction of state support and felt the college could be strengthened by raising funds for scholarships, increasing the endowment, and making people more aware that public colleges needed private giving to ensure the best opportunities for the future. Shown in this photograph are, from left to right, Clifton R. Wharton Jr., SUNY chancellor; Dolores Wharton; Marion Craven; and Clifford J. Craven, Oneonta president.

**COLLEGE CAMP: AN OUTDOOR RESOURCE REOPENED, 2000–2001.** While the College at Oneonta has many facilities, there are none that can compare to the College Camp for the outdoor enthusiast. Closed since 1992 because of budget constraints, the camp was reopened in 2000 after a partnership was formed between the college, Student Association, and the Organization of Ancillary Services Board of Directors. Among the camp's facilities are the Lodge, with kitchen and great rooms with fireplaces, 10 campsites, a ropes course, nature trail, tobogganing hills, open fields, picnic areas, eight miles of trails, two ponds, a warming hut, and the observatory. Many events were held at the camp, including concerts, picnics, weddings, conferences, retreats, summer day camp, and many others. After a three-year evaluation period, the partners will determine if the College Camp has become a viable educational resource. (Courtesy of College at Oneonta Public Relations Office.)

121

THE STUDENT ASSOCIATION AND GOVERNANCE AT THE BEGINNING OF THE NEW CENTURY, 2000. The Student Association is an organization consisting of students who have paid the mandatory fee each semester. The main purpose is to enrich campus life by offering many activities as well as services (and financing) to students. There are more than 70 clubs that work on promoting campus involvement through lectures, concerts, fundraisers, and other events. The Student Senate, the policy-making body, is made up of one representative elected for every 200 students. The Student Association, through the Student Senate, votes on the funding of clubs, which are in five categories: academic, cultural enrichment, performance organizations, special interest groups, and athletic clubs. Publications including the *State Times,* the *Oneontan,* and *Art and Scope* are also supported. The photograph shows recent officers of the Student Senate. They are, from left to right, Edmond Lugo, treasurer; Christina Donato, assistant treasurer; Molly Dolan, vice president; and Adam Wallach, president. (Courtesy of the Student Association.)

DR. VINCENT F. AND GAIL (BRANDI) FOTI, ALUMNI SERVICE PERSONIFIED, 2000. Vince and Gail Foti are true Oneonta supporters. Vince worked at the college for nearly 30 years in a number of progressively responsible positions, serving as associate dean of students, associate dean for academic administration, director of Academic Advisement, and retiring as dean of behavioral and applied science. Some of his best contributions were in such roles as developing articulation agreements with selected high schools, being a liaison with other institutions of higher learning, and advising and supporting the athletic and physical education departments, including serving currently on their Hall of Fame Committee. He and Gail are enthusiastic alumni supporters. Vince, a recipient of the Alumni Association Award, served as president of the Oneonta Alumni Association. He has an endowed scholarship (established in his honor) that helps assure a good start for some bright and deserving students of the future. Vince and Gail Foti represent, in the best sense, what the College of Oneonta is all about when it speaks of character, service, and making the future better for all concerned.

**THE COLLEGE FOUNDATION: TWO DECADES OF PHILANTHROPY AND SPIRIT, 1982–2002.** In late 1981, Dr. Clifford Craven, president of the college, wanted to try something new: the raising of private funds to assist the college. He said that additional money would provide a "margin of excellence," strengthen the Oneonta Alumni Association, and help create a tradition of giving. A new foundation was formed, and the first campaign reached its goal of $250,000 in 1987. Dr. Alan Donovan, on becoming the sixth president in 1988, reinforced the idea of supporting the college. The most successful financial effort that ensued was the Campaign for Oneonta, designed to increase the foundation endowment and aid other facilities. By June 1999, the fund had raised $11.8 million. Today, the foundation has assets of $16 million. Pictured, from left to right, are Alan B. Donovan, president; Granville Thompson (Class of 1968), alumni association president; Karen Elting (Class of 1984), board president; and Thomas Hughson, board president (1992–1999). (Courtesy of "College at Oneonta Foundation: Twenty Years of Philanthropy and Spirit" and Paul Adamo.)

**THE CENTER FOR MULTICULTURAL EXPERIENCES: KNOWING OTHERS, 2000.** The center, located in Lee Hall, provides social, spiritual, and academic support to students of color and international students. The idea of a center for these activities came from Dr. Grace Jones, vice president for Multicultural Affairs in the early 1990s. The facility is open to everyone and is frequently the scene of festivals, celebrations of significant holidays, and observances. (Courtesy of the 1994 *Oneontan* and the 2000–2001 College at Oneonta undergraduate catalog.)

**DR. ALAN B. DONOVAN: CHARACTER BUILDING FOR THE NEW CENTURY, 1997 AND 1999.** "We are extremely honored by the Templeton Foundation's recognition," said President Donovan. "It is a tribute to our continuing focus on students' personal, cultural, and ethical development as well as academic excellence." Donovan was speaking at the awards ceremony in Washington, D.C., where the College at Oneonta received a national award for being recognized as having such an exemplary program that it was listed in 1997–1998 John Templeton Foundation Honor Roll for Character-Building Colleges, a distinction recognizing colleges and universities that emphasize character building as an integral element of the college experience. Oneonta was one of only 135 American institutions selected. The honor was repeated in 1999, attesting to the steadiness of the college's commitment to the importance of students understanding personal and civic responsibility. In 2001, Oneonta was named again, the only SUNY college listed. Throughout his tenure at Oneonta, Donovan has concentrated on organizational changes that have stressed effective citizenship, public service, dedication to the college as parents and alumni, and a compassionate attitude toward those of different ethnic origins. For Oneonta, the building of character in its students is a tradition that is being effectively carried forward into the new century. (Courtesy of College at Oneonta Public Relations Office.)

**DR. JOSEPH F. CHIANG CONDUCTS FLY ASH RESEARCH 1992.** During the last half century, Oneonta has had several outstanding scientists on its faculty. Among them is Dr. Joseph F. Chiang, who has been on the cutting edge of materials research for the last 30 years. Currently, he is involved in research concerning nanotubes, superconductors, and the latest materials science. He is a patent holder for a process converting fly ash emissions from coal-burning plants into ceramic glass. Chiang holds a Ph.D. in chemistry from Cornell University. He has been awarded numerous awards, including being the first recipient of the Distinguished Alumni Lectureship by Tunghai University in Taiwan. He has received several grants from various agencies. This photograph shows Chiang (right) and Huemac Garcia, community project manager, inspecting fly ash at the New York State Electric and Gas Jennison Station power plant in Bainbridge, New York. (Courtesy of College at Oneonta Public Relations Office.)

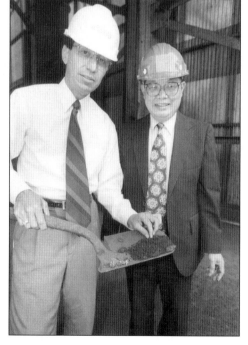

**THE CENTER FOR ECONOMIC AND COMMUNITY DEVELOPMENT, 1990.** The center's mission is to link the human and physical resources of the college with business and community organizations. It also coordinates a wide array of resources and services for the purpose of linking education, research, and public service. Established in 1990 by Dr. Alan Donovan (president of SUNY College at Oneonta), the center is part of the division of College Advancement, which works to strengthen the resources of the college through contracts, grants, and contributions. The center is a research and problem-solving resource with a focus on projects that require in-depth research and the development of creative strategies to address challenges facing people, organizations, and municipalities. The center develops collaborative relationships to implement strategies and action plans that address such issues as downtown revitalization, economic impact analysis, community surveys, tourism analysis, small business training, and nonprofit organizational development. Facilitating meetings, planning conference formats, arranging for lodging, having the center staff help organize conferences are some of the many services that the center provides to businesses or other clientele.

**THE CENTER FOR SOCIAL RESPONSIBILITY AND COMMUNITY, 1990.** The mission of the center is to instill in the students a sense of understanding of its relationship to building strong communities. Service agencies derive many benefits from their connections to the college—gaining the involvement of educated students, building strong relationships with the academic institutions, and inspiring young people to pursue a career in the agency's field. Projects or tasks may last a semester or more with programs such as day-care centers, Boy Scouts and Girl Scouts, nursing homes, and the United Way. Onetime jobs may last only a few hours per day and may include serving in a hot-meal program or helping with the Special Olympics. The center works with Americorps, American Humanics, and Student Service Information and Referral. This photograph shows staff members and students completing a project for the United Way.

**THE ALUMNI FIELD HOUSE: A DREAM REALIZED, 1999.** The field house has been the dream of Oneonta's last three presidents. Over the last 30 years, it has been the casualty of the budget process, economic downturns, political prioritization, and just plain wrangling. It is a tribute to the Oneonta administrations, past and present, that they stayed the course, submitting plans, cost estimates, and updates in a timely manner, and answering every inquiry with the direct reply that Oneonta students deserve and need this facility. The field house is the newest structure on the campus, completed in 1999. It opened in August and had an inaugural concert in the Dewar Arena by singer Tony Bennett. The 92,0000-square-foot building cost approximately $15 million. A dance studio, three basketball courts, an elevated indoor track, a weight-training and fitness center, and faculty offices are also housed in the building. In 2000, a new soccer field was constructed next to the field house, making maximum use of the entire site. (Courtesy of Oneonta Alumni Association and Dr. Leif Hartmark.)

Soccer Field Rehabilitation
Artist's Impression

DR. MICHAEL E. LYNCH, DIRECTOR OF THE ALBANY AND WASHINGTON INTERNSHIP PROGRAMS, MAKES AN AWARD, 1992. More than 30 years ago, the political science department introduced liberal arts internships at Oneonta. Students benefit greatly in terms of knowledge of government and politics, career exploration, personal growth, self-confidence, and computer and writing skills. Each intern is individually mentored and supervised by Dr. Michael E. Lynch, chair of political science. In this photograph, Lynch is awarding the Arnold S. Harris Memorial Award to John W. O'Rourke, an outstanding political science major. Arnold S. Harris was a believer in public service and off-campus experiences, and remembering him by honoring promising students is entirely appropriate. (Courtesy of the political science department.)

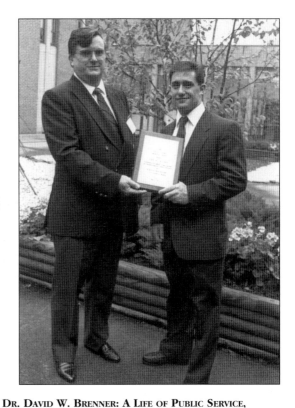

DR. DAVID W. BRENNER: A LIFE OF PUBLIC SERVICE, 1960–2001. David W. Brenner (Class of 1957, 1959G) exemplifies the term "public service." Coming to Oneonta after stints in the service, he was a member of the veterans' group that helped increase enrollments in the early 1950s. Returning to his alma mater in 1960, he served as assistant professor of social sciences, supervisor of student teachers, director of registration, college registrar, associate dean of academic affairs, and associate vice president for academic affairs before retiring in 1993. In public life, he served as legislative assistant, vice chairman and chairman of the Otsego County Board of Representatives for several years, and as mayor of the city of Oneonta for 12 years before retiring at the end of his term in 1997. He has received several awards for his efforts, including the SUNY Chancellor's Award for Professional Services (1978), Hartwick College Citizens' Board Outstanding Citizen of the Year (1997), Oneonta Area NAACP Thurgood Marshall Unity Award (1993), New York State American Legion Meritorious Service Medal (1999), Planned Parenthood's Maurice Bridges Award, Meritorious Alumni Award (1970), Distinguished Alumni Honor Roll (1994), and others. Brenner continues his affiliation and support of the College at Oneonta by supporting an endowed scholarship in his name and serving as chair of the College Council.

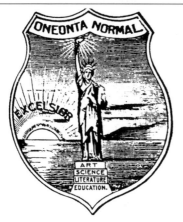

**PREPARING FOR THE NEW CENTURY, 2001.** The College at Oneonta has completed its first century—and a few years beyond. The mission of the college is to foster students' intellectual, personal, and civic development. Dedicated to achieving and maintaining excellence in teaching, advisement, and scholarly activities, the college seeks to cultivate a campus environment rich in opportunities for participation, personal challenge, and service. To accomplish these goals, Oneonta will be the first-choice college for those who are intellectually talented and motivated. It will offer high-quality academic programs, including innovative teaching, technological support, and opportunities for student involvement. Oneonta will also provide the best setting for students' academic and personal development, as well as a safe environment that encourages diversity, volunteerism, and training for community leadership. The goal of delivering informed and productive citizens who have developed skills in critical thinking and are able to make ethical decisions remains the major challenge. The College at Oneonta, built on honor and good faith and concerned with the character of young people, has a very good chance of accomplishing its objectives.